THE GRAPHIC DESIGNER'S BUSINESS SURVIVAL GUIDE

Lawrence J. Daniels

AMACOM

AMERICAN MANAGEMENT ASSOCIATION
New York · Atlanta · Brussels · Chicago · Mexico City
San Francisco · Shanghai · Tokyo · Toronto · Washington, D.C.

Bulk discounts available. For details visit:
www.amacombooks.org/go/specialsales
Or contact special sales:
Phone: 800-250-5308
Email: specialsls@amanet.org
View all the AMACOM titles at: www.amacombooks.org

This publication is designed to provide accurate and authoritative information in regard to the subject matter covered. It is sold with the understanding that the publisher is not engaged in rendering legal, accounting, or other professional service. If legal advice or other expert assistance is required, the services of a competent professional person should be sought.

Library of Congress Cataloging-in-Publication Data

Daniels, Lawrence J., 1942–
 The graphic designer's business survival guide / Lawrence J. Daniels.
 p. cm.
 Includes index.
 ISBN 978-0-8144-3241-9 (pbk.)—ISBN 0-8144-3241-7 (pbk.) 1. Graphic arts—Vocational guidance. 2. Graphic arts—Practice. 3. Small business—Management. I. Title.
 NC1001.D36 2013
 741.6068—dc23

 2012025183

About AMA
American Management Association (www.amanet.org) is a world leader in talent development, advancing the skills of individuals to drive business success. Our mission is to support the goals of individuals and organizations through a complete range of products and services, including classroom and virtual seminars, webcasts, webinars, podcasts, conferences, corporate and government solutions, business books, and research. AMA's approach to improving performance combines experiential learning—learning through doing—with opportunities for ongoing professional growth at every step of one's career journey.

Printing number
10 9 8 7 6 5 4 3 2 1

CONTENTS

List of Figures vii
About the Author ix
Preface xi

1 TAKING THE PLUNGE: A DAUNTING, ENERGIZING JOURNEY 1

Facing the reality of entrepreneurship

Early missteps: an object lesson

Partnering: a marriage of convenience?

Do you really need a business plan?

Building a brand voice

2 SETTING UP HOUSE: FIRM FUNDAMENTALS 21

Self-discipline: the first key to success

How should I structure my business?

Bookkeeping: why some things are better left to others

Location, location, location? Not so much anymore

Vendors: strategic alliances you can't grow without

The lowdown on markups

You're not alone: tales and tips from other creatives

3 DESIGN FIRM MANAGEMENT: TOOLS AND TEMPLATES 47

Managing big-budget costs

The print production specsheet

Cashing in on media commissions

Tracking sales efforts

Assigning project identification: the key to efficient
administration

Time tracking: the key to managing profit

The ledger: documenting and tracking receivables

Invoicing: structuring how you get paid

Managing cash flow

Progressive billing: the key to staying solvent

4 DESIGNING A RELEVANT FIRM IMAGE 65

Focusing on a defined practice area

Defining your USP

Designing for business

Showcasing your qualifications

5 COMMUNICATING CREDIBILITY 81

Shaping an image that shapes perception

Getting to know your prospect: pre-pitch research

Honing presentation skills

Overcoming jitters

6 EFFECTIVE BUSINESS WRITING: THE CORNERSTONE
OF FIRM GROWTH 93

Good design is no excuse for bad writing

The new contact introduction letter

The follow-up letter

7 CRAFTING A WINNING PROPOSAL 101

Composing the *real* art of the deal

Establishing creative methodology

8 TIME MANAGEMENT: THE KEY TO DESIGN
FIRM PROFITABILITY 121

Juggling the time clock

Establishing baseline time rates

Establishing billable time rates

Tracking billable time

The new project start-up package

Tracking billing information

Project content folders

Tracking progressive expenses

Handling downtime

9 EFFECTIVE MARKETING: YOUR PASSPORT
TO SUCCESS 139

Sales: an unavoidable reality

Absorb like a sponge

The importance of taking a worldview

Self-promotion

Testimonials: harnessing the power of praise

Capitalizing on peer recognition

Taking the chill out of cold calling

Promotional marketing

Avoiding the "eggs in one basket" predicament

10 GROWING YOUR FIRM IN ANY ECONOMIC
CLIMATE 187

"We" vs. "me": the art of shaping perception

Leveling the playing field

Corporate chemistry: adapting to cultures and
personalities

Hooking the big fish

Mining the media

Mining other income streams

The nondisclosure agreement

11 SIDESTEPPING OBSTACLES IN YOUR FIRM'S PATH 207

Getting past the gatekeepers

Dealing with deadbeats

When good projects go bad

A sobering reality . . . and a bright outlook

A final word (or two)

Index 223

FIGURES

FIGURE 3-1 Print Production Specsheet* 50

FIGURE 3-2 Insertion Order Template* 55

FIGURE 3-3 Sales Contact Tracking Log* 57

FIGURE 4-1 Girl Scouts Graphic Guidelines Manual 76

FIGURE 4-2 AssetSight Identity and Stationery System 77

FIGURE 4-3 Bass & Howes Flexible Marketing Portfolio 77

FIGURE 7-1 Creative Brief* 107

FIGURE 7-2 Proposal Worksheet* 110

FIGURE 8-1 Daily Time Sheet* 125

FIGURE 8-2 Time Summary Sheet* 126

FIGURE 8-3 Project Cost Summary Sheet* 128

FIGURE 8-4 Proposal/Work Authorization Entry Log* 129

FIGURE 8-5 Project Cover Sheet* 131

FIGURE 8-6 Project Trafficking Sheet* 133

FIGURE 8-7 Progressive Project Expense Sheet* 134

FIGURE 9-1 1995 Holiday Card with Gold Champagne
 Bubbles 149

FIGURE 9-2 2006 Holiday Card 150

FIGURE 9-3 "Toast to Life" Holiday Card 151

FIGURE 9-4 Generic B2B Ad 174

FIGURE 9-5 Pro Bono Ad Prototype 179

FIGURE 10-1 "Brand Doctor" Prototype Column 199

FIGURE 10-2 "Heat" Concept Proposal 201

FIGURE 10-3 "Heat" Prototype Packaging 202

*The starred forms are available for download at www.amacombooks
.org/go/GraphDesign.

ABOUT THE AUTHOR

Larry Daniels is the recipient of virtually every major industry recognition for outstanding achievement in communications design, including several "Best of Show" honors from the Art Directors Clubs of New York and New Jersey, the Advertising Clubs of New York and Westchester, the Creativity Awards, and American Corporate Identity, among many others. His work has been the subject of several professional and business publications, and he has spoken on the use of design as a quantifiable business tool in his role as an adjunct lecturer at New York's City College.

Having provided strategic branding and marketing communications to a broad spectrum of clients ranging from start-ups to Fortune 500 companies as principal of DanielsDesign, Larry now shares his extensive experience with other design entrepreneurs who want to break out of the freelance mode and enter the realm of highly valued—and handsomely compensated—creative resources.

PREFACE

With some three out of ten graphic designers self-employed—almost five times the number for all professional and related occupations*—many would-be entrepreneurs can readily attest to the fact that starting and running a successful design firm takes far more than raw talent; it takes determination, discipline, and above all, a large measure of business savvy—something woefully lacking in design school training.

The guide you're holding isn't like any other "self-help" book you'll find. While others are generally interspersed with contributors' project examples and commentary, you'll discover that *The Graphic Designer's Business Survival Guide* is focused *exclusively* on the *business* aspects of helping you to build, manage, and grow your small design consultancy from the ground up.

This is taken directly from the playbook of someone who

* Out of a total of 286,000 graphic designers employed as of June 2011, 27 percent are self-employed, not including incorporated business owners (most of whom run one- to five-person firms. *Bureau of Labor Statistics' Occupational Outlook Handbook* (Washington, D.C.: U.S. Department of Labor, June 2011).

has seen it all during some four decades in the business of communications design. I share experience and insights one-on-one with the reader, providing inside information on how to structure and manage a profitable design firm, develop a unique market niche, pitch and land high-value clients, and build lasting professional relationships. It will cover the ups and downs, highs and lows, and ins and outs of delivering targeted creative services to clients who look beyond aesthetics and expect a high return on their investment, whatever their marketing objective may be.

All along the journey, from starting out as just another freelancer to becoming sought after as a valued creative resource, the reader will find that *The Graphic Designer's Business Survival Guide* provides the *real* keys to success in this business: being able to "walk the walk" and "talk the talk" with clients and prospects by communicating with them on *their* playing field; not only by delivering smart and attractive design solutions, but also by being able to *quantify* those decisions in ways that business clients can relate to, understand, and respect.

If your goal is independence, creative satisfaction, a good income, and enough free time to enjoy life outside of the design business, this guide is certain to become a timeless and indispensable reference tool for you.

1

TAKING THE PLUNGE

A daunting, energizing journey

FACING THE REALITY OF ENTREPRENEURSHIP

Most graphic designers I've come in contact with over the years have at least entertained thoughts of "going it alone" at some point in their careers. Some have done it successfully; many have not. For those who have not, lack of raw talent was almost never the reason for failure; lack of business know-how almost always was.

The reality, of course, is that no matter how business savvy you may be, entrepreneurship is not for everyone. Consider, for example, that while design ability may be at the core of any successful design firm, you'll probably devote no more than half (often more like a quarter) of your time to the actual process of designing once you're the principal of a one- or two-person firm. Sales, client interactions, project management, and the various administrative functions required to run a business tend to take up a far greater role than many would-be entrepreneurs have the knowledge—or stomach—for. And speaking of stomach upheavals, before you decide to take the plunge, you'd do well to reflect carefully on the roller-coaster ups and downs of those inevitable business cycles that often make a steady paycheck a very attractive and satisfying alternative to operating your own business.

Finally, there's the issue of eventual net worth. With most other types of business, entrepreneurs work hard to grow their ventures with an eye toward building cumulative value and then eventually either passing the business on or profiting from its sale. If this is your goal, the design business is probably not for you. While it may be true that a few large design firms have been acquired by larger companies, the market for "boutique" shops is clearly not appealing as a solid business investment. Think about it: annualized sales volume that's more often than not dependent on iffy project-by-project assignments; no long-term contracts or

projections; spotty cash flow; no real property holdings; no inventory; and, especially in the breakneck pace of digital innovation, constantly depreciating equipment value. Add to that equation the fact that most client/resource relationships are personality driven and won't transition easily, if at all, to new management—and you can see that this is certainly not an enticing picture for potential investors.

There is a bright side, though, and it's this: Just about *every* designer I've ever known would happily characterize this career choice as one that he or she wouldn't want to trade—something that sadly is beyond realization for the vast majority of the working populace. And so, the question you must answer is: Do you think you have what it takes to succeed in this often difficult, often rewarding business of ours? If so, read on and get ready for what could be the ride of your life.

EARLY MISSTEPS
An object lesson

If you fit the profile of most aspiring graphic design entrepreneurs, your story goes something like this: after design school, you probably entered the workforce with an over-inflated level of confidence in your abilities and a portfolio of class assignments to prove it. But soon after coming to grips with the reality of job rejection after sobering rejection, you finally landed a bottom-rung position only to realize that there's so much more to learn in the "real world" than you were ever

made aware of in school. Suddenly you were faced with the realities of design not purely as an aesthetic exercise, but as a real-world problem-solving profession replete with deadlines, project management issues, budget matters, marketing questions, client and colleague interactions, and, of course, subjectivity—the profession's number-one ego deflater.

If you're anything like I was, you quickly realized your shortcomings and tried to absorb the workings of a real business enterprise as quickly and completely as you could. Truth be told, I felt so unprepared at the beginning of my career that I thought of quitting it before I ever really got started. Looking back, my early career path was a seat-of-the-pants journey that only began to stabilize some five years after going from job to job (and only some of those changes by choice). I worked for a printer, two design firms, and two ad agencies before I finally felt competent enough to begin freelancing—and then only on a supplemental basis. It wasn't until *years* after I had begun my career that I finally felt confident enough to take the plunge and go into freelancing full-time. And when I did, my client base was composed mainly of the few contacts I had made within the industry to feed me work, often on their premises. It didn't take me long to realize that this work-for-hire arrangement was basically a dead-end for my aspirations of running my own show. I found myself working at fixed hourly rates with no guarantees, no benefits, no opportunity for advancement, and no time to build a real business of my own.

My first big mistake was painfully realized when I bit the hand that fed me by directly contacting one of my clients' clients in an attempt to win him over. To my thinking at the time, my rationale seemed to be a compelling one for him: Since I was doing the work anyway, why wouldn't this client leap at the chance to deal directly with me and forgo the markup that he was likely being charged by my client? A seemingly sound argument except for one major factor that I hadn't considered: the strength of the bond that my client and his client shared—a genuine sense of trust and friendship that apparently transcended both creative output and compensation. As you can imagine, the end result was that I lost someone I had long considered both a client and a friend. It was a hard lesson that I wouldn't soon forget.

After recovering from that debacle, I attempted to figure out what it was I could do to grow my fledging business beyond the freelance stage. My limited dealings with full-service design firms convinced me that by now I possessed the raw talent to compete for a slice of the larger pie. What I realized I *didn't* possess, however, was the business acumen, time, or funding needed to make my vision a reality.

By that time, I was newly married with all of the financial and social responsibilities that come with that commitment. But unlike before, I felt the pressure of being backed into a corner with the need to bring home a steady paycheck instead of constantly running on what I had come to view as a never-ending treadmill of drumming up business,

doing the work, and repeating the effort all over again. And so, I tried to objectively weigh both the positive and negative sides of staying the course as an independent versus working for someone else. From a practical viewpoint, the "someone else" side always won out, but I knew that if I took that route, I'd invariably be wondering "what if": What if I took the less challenging road of steady employment? What if I were to get fired at some point when I was too old or too entrenched with financial responsibilities to start over? What if I passed on the chance to build a real business for my family?

No doubt you've asked yourself these very same questions—and, since you're reading this guide, chances are you came up with the same answer as I did then: I'd never forgive myself if I didn't at least make an effort to "go it alone." Realistically, I knew there had to be a better way to achieve my goal of building a respected and profitable design business, but how?

In the end I convinced myself that what I needed was a partner; someone whose vision and strengths would complement mine while taking some of the pressure off my back. The problem was, since I really didn't have much to offer beside talent and desire, who would ever want to partner with me? It was a question that I knew would be answered more equitably once I had a record of business experience and sales behind me.

PARTNERING
A marriage of convenience?

With the decision made to stay the course as an independent designer, I'd taken the plunge and rented a small office suite in midtown Manhattan. The burden of coming up with the rent each month plus attempting to draw a regular salary was the motivation I needed to get out and hustle for business. All fine and good except that soon enough, the old problem of not being able to juggle all of the things that needed juggling really wore on me. I was spreading myself too thin, not spending enough time on any of the critical elements of my business that I knew demanded my attention. And so, the never-too-far-from-the-surface partnership question once again moved onto the front burner.

As I had done before, I convinced myself that a partnership would allow me the freedom to further hone my design skills by shifting the burden of having to deal with all of those other business-related issues to someone else. Sure, I was aware of some design-only partnerships that on the surface at least seemed to work well, but I really couldn't see how partnering with another designer would help me to realize my goal of growing a real business. Maybe it was my ego advising me, but to my mind, I wanted to partner with someone who would be able to *complement* my strengths, not compete with them.

The question was, how could I ever find such a person, and what could I possibly offer to persuade him or her to join up with me? I had no real track record, no contractual clients, and no real prospects other than my gut feeling that together, we could possibly build a viable business and in turn, realize a dream.

Somewhat ironically, the person I was searching for turned out to be one of several marketing managers as well as my primary contact at one of my clients, a worldwide delivery company. I broached the subject with him in an offhanded way over lunch one day and was genuinely surprised when he responded that he too was looking to go out on his own. After several weeks of back-and-forth negotiations, we had convinced ourselves that a partnership was at least worth a try, and thus had an attorney draw up a pretty straightforward agreement that we both endorsed.

It took only a few months for it to become painfully clear that the core business we had counted on from his previous employer had begun to dry up. Why? Who's to say? Maybe he ticked someone off; maybe it was a payback thing. Whatever happened, happened. We just had to try to move on. Thankfully, in relatively short order, we landed another anchor client, a small, family-owned natural cosmetics company. This time around, though, instead of employing my usual approach of simply relying on handshakes and verbal assurances, my partner proved his worth by securing what was for us at the time a generous monthly retainer

agreement—one that at the very least covered a few of our basic ongoing expenses. The retainer provided the cushion we desperately needed in order to prospect for additional business opportunities.

Our agreement with this client was fairly straightforward—structured to cover a set number of creative and production hours at reduced time rates in order to make the agreement appealing to the client. In the following sample agreement, I've plugged in an arbitrary dollar amount that you can adjust to suit your own circumstances if you decide to go this route. Take a look:

Retainer Agreement Between (Your Legal Firm Name) and (Client's Legal Name)

When endorsed by both parties, this agreement will cover services to be provided by (your firm name—hereinafter referred to as "us/we/our") to (client name—hereinafter referred to as "you") for a period of one year commencing on the date of endorsement.

In consideration of a $12,000 annual retainer fee to be paid in 12 equal installments, we agree to provide your company a full range of unrestricted design and marketing services within our capabilities. Such services may include consultation and market research, graphic design planning

and execution, copywriting, and pre-production services as may be required on project assignments initiated by you or by your designated counterparts.

Our fee basis of $1,000 per month is to be apportioned at specially reduced time rates of $100 per hour for creative services and $65 per hour for production services. We agree to maintain detailed time records of all work performed under the terms of this agreement for your review if requested. Any additional time that may be required within any monthly period must be authorized by management in writing. Invoicing will only be issued for work performed beyond the scope of this agreement as well as for all documented out-of-pocket expenses incurred in conjunction with assigned projects. All invoices are payable in full within 30 days of issue.

Work performed under the terms of this agreement is based on a regular five-day, 40-hour work week exclusive of weekends or overtime. Retainer payments are due by the third day of the month following.

This agreement is subject to review six months from the date of inception.

Accepted by:

X _____ ___/ ___/ ___
Client's signature Date

Client's name and title

X _____ ___/ ___/ ___
Your signature Date

Your name and title

Our relationship with that client was both productive and congenial during the two-plus years that it lasted. Toward the end of the second year, however, we were made aware of a medical condition that forced the company's CEO to withdraw from active participation in his business. In short order, the company reins were passed down to his son-in-law, who, no doubt seeking to put his own stamp on the business—as many do in such circumstances—opted to replace us with sources of his own choosing.

Losing that piece of business effectively put the kiss of death on our partnership. Much like a bad marriage, accusations began flying and a bitter "divorce" ensued—one that had to be settled monetarily because of the contractual terms that we both had agreed to. I ended up buying out his share of what was left of our firm only to discover soon afterward that he was attempting to solicit that very same client again behind my back—shades of *my* earlier mistake—except that this time, that breach cost him the remaining payout that we had negotiated. This, by the way, is just one of many good reasons to get all agreements in writing and to cover all contingencies.

Over the years since, I revisited the idea of entering into a partnership arrangement on two other occasions when I'd convinced myself that it would ease my burden financially and creatively, and help to grow my business beyond what I thought I was able to handle by myself. Those attempts included a client of mine who ran a small public relations agency and a colleague whom I had brought in to work with me on a couple of projects. This time around, prior to entering into possible negotiations, I asked both of these potential candidates to write down their thoughts concerning a possible partnership. Specifically, I wanted to know:

- How they viewed our respective roles in the proposed partnership
- What their expectations were for our business
- Whether we were on the same page creatively

- Whether they foresaw any roadblocks in terms of their personal lives
- Whether they were willing to invest capital as well as time in making a go of our venture
- How they viewed me personally as a potential partner

Of course, I also completed this assessment for each of them. The results of that exercise were both interesting and revealing. I suppose that both of these "tryouts" were shaded by my past experience and so, with cold feet on my part, neither came to fruition. Naturally, I'll never know how those decisions might've affected my business, but looking back, I really have no regrets. Given my past experience, I realized that, for all of the positives that I envisioned, I really didn't want the excess "baggage" of a partnership in terms of my being able to carry out decisions and directions that I may have felt were needed once the "honeymoon" period was over.

I know I'm jumping the gun in talking about partnerships this early in the guide, but since that's a situation I fell into early on, I thought my experiences might be of value to you too. Should you consider a partnership? My advice would be this:

1. As opportune as forming a partnership may seem at the time, build a track record for yourself first. Doing so will give you the confidence—and the leverage—you'll need to enter the partnership equitably.

2. Be aware that partnerships are subject to change over time. Creative differences, financial circumstances, and emotional upheavals, whether related to business or to family, can derail even the strongest relationships.

3. If or when you do decide to enter into a partnership, treat the agreement as if it were a marriage contract—one with an ironclad prenup. Secure the services of a competent attorney and be sure to carefully define the roles, responsibilities, and exit strategies of both parties.

DO YOU REALLY NEED A BUSINESS PLAN?

Let me begin this section by admitting that since being out on my own, I've never worked within the confines of a formally structured business plan. While others will tell you that they're a necessary tool for defining goals and tracking progress, I've always found them to be altogether too static and confining. The truth is, if your business model follows mine—and I've found that most creative boutiques do—the scope of your operation is bound to shift over time anyway, so why waste your time preparing a plan that you'll likely come to ignore as circumstances change?

That is, of course, unless you're planning to raise working capital for your firm. In that case you *will* need to prepare a business plan.

When my firm was first incorporated as Daniels/Goldberg Associates, the partner I had at the time wrote a

detailed business plan that we dutifully submitted to the Small Business Administration (SBA) in the hopes of getting a low-cost government loan to jump-start our fledgling company. A business school grad, he was well versed in writing these and had high expectations that the loan would be granted. I had my doubts. As it turned out, so did the SBA, as well as private parties to which we submitted it. To get a loan you need to show that you will be able to pay it back—something that can be difficult to demonstrate when your income is largely earned project by project.

Nevertheless, if you do feel that you need or want a business plan, you can choose one of the many models available on the Internet and adapt it to your own criteria.

BUILDING A BRAND VOICE

After dissolving our partnership some three years after it was formed, I renamed my firm Lawrence Daniels & Friends. Because of the commonality of my surname, adding "& Friends" seemed to be the only way I was able to get corporate approval from the New York secretary of state. The new firm name certainly proved to be both unique and memorable, and resonated positively within the publishing, school, and not-for-profit sectors where I continued to build my business. The work in these areas was creative, steady, and satisfying, and I was a happy camper—happy, that is, until I slowly came to realize that because rates

were generally standardized at the low end of the pay scale among these market segments, I'd probably never be able to realize much more in sales than I was currently billing. Besides, by now I was really itching to shift the business focus toward the more lucrative, more prestigious area of corporate design. In order to do that, the time had come to take a hard, objective look at where I was as a designer, where I wanted to go, and how to get there given my current circumstances.

How, for example, do clients, prospects, and colleagues perceive my firm? Do they recognize it as a real business entity or as a freelancer trying to effect a broader role? Is the firm being taken seriously enough? Will raising my visibility as a creative resource bring in more and better business? Is this the market niche that I want to stay with? Where did I want my firm to be five years from now?

Those were all tough questions, but ones that I knew had to be answered if I ever hoped to shift the direction I wanted to take. After thinking long and hard about it, I boiled down my strategy for getting there to one compound objective: increase name recognition, and work to project an image of a firm larger than the sum of its parts. Easy to state, difficult to accomplish.

I began the process of implementing my plan by changing the firm name to DanielsDesign in an effort to communicate a more businesslike persona. I had struggled with the renaming issue for some time, seriously considering using

a more generic-sounding firm name in order to distance myself from being so closely tied to the firm. My thinking at the time was that by including my name as a component of the business identity, the firm would never be perceived as anything larger than a one-person operation, which would therefore limit my chances of ever expanding its scope. On the other hand, incorporating my name into the masthead was a reality check to clients that I wasn't trying to overextend my reach; it was a means of assuring them, and assuring myself, that the personal commitment I had made back when I opened the doors—to continue to stand behind every assignment entrusted to the firm—was as resolute as ever. Bottom line: The "other hand" rationalization won out.

Part two of my plan was to increase active participation in industry awards shows and to contribute articles to professional publications. The idea was to promote myself on a systematic basis and then try to leverage the results among my target audience.

The awards shows, while time consuming and somewhat costly to prepare for, provided much more than an ego boost; they supplied a platform for my work to be seen and noted by a far wider audience of both peers and prospects than I ever could've accomplished on my own. Beyond peer recognition, the certificates displayed on my walls and website sent a not-so-subliminal message of professionalism and competence to visitors, the majority of whom were clients and prospective clients, folks who have no particu-

lar connection to the design industry beyond their dealings with the firms they hire.

Contributing commentary to trade journals proved to be an even more time-consuming undertaking, but one that proved its value in boosting awareness and credibility for me. Because these publications generally don't pay for articles, you'd be surprised (I was, anyway) at how receptive editors can be when you submit a story that they feel will resonate with their audience, you have some professional credentials to back up your byline, you're a halfway decent writer, and they're looking to fill space in their magazine.

The articles that were picked up for publication generally focused on problem solving from a design perspective— situations and solutions taken from firsthand experience and broad enough in scope to be of interest to the publication's readership. I was even able to work out a reciprocal trade arrangement with the publisher of a respected group of trade magazines to design two of their covers (with a photo and bio inside) and run free full- and half-page ads for my firm in their flagship publication.

What were the results of this self-promotion? While I can't point to any single piece of business coming to me as a *direct* consequence of these efforts, I can tell you that they definitely had a cumulative effect in building prestige and name recognition for me, and increasing awareness for the firm—attributes that would help me to transition away from

publishing and not-for-profits and toward the more profit-able corporate sector that I had targeted.

Building a recognizable brand voice for your business in these ways is essential to its success. The best part is that it takes only a commitment of your time, talent, and an incon-sequential amount of money to begin to see results. These are points you might want to consider as you struggle with the evolution of a business model that will help you to real-ize your goals.

I believe that my firm has survived—and prospered—over the years for four simple reasons: (1) I'm good at what I do and it shows; (2) I love the fact that this business allows me to interact with so many others; (3) I've made a concerted effort to understand the role of graphic design as a compo-nent of business strategy; and (4) I was determined not to work for anyone else. I would imagine that most readers of this guide feel the same way.

2

SETTING UP HOUSE

Firm fundamentals

SELF-DISCIPLINE
The first key to success

The great "I'm my own boss" fallacy, which people who work for others like to believe, is that because you run your own business, you're free to set your own hours and generally enjoy a bigger paycheck and more free time than they do. If only that were true! In fact, the pressures and responsibilities involved in operating a small design firm— or any small business for that matter—require an enormous degree of self-discipline and motivation. If you're a procrastinator, especially when it comes to doing things

that you really don't want to tackle, and you're thinking of making a go of your venture, I have three words for you: *Get Over It!*

The one big mistake that most freelancers make is not having the self-discipline to prioritize work and downtime in order to make the most of each. For me, creating an orderly work environment is the first key to establishing the disciplined approach necessary to managing the various tasks involved in running an efficient operation. "Neatness Counts" is not just something your elementary school teacher emphasized; it's an essential mantra when your goal is always knowing where everything is and establishing a compartmentalized sense of order that shows you're in control of your surroundings and not the other way around. I maintain a "to do" list that I update every evening so that I don't have to scramble to retrieve notes or try to recall phone conversations the next morning. The list, kept on my computer desktop, is prioritized into sections labeled "work in progress," "appointments," and "due dates." This last category includes such things as my lease expiration, professional dues renewals, and city, state, and federal tax filing deadlines—plus, of course, project deadlines.

As a matter of survival, I've developed a series of procedures and forms to aid in this effort. These issues and templates are covered in the chapters that follow.

HOW SHOULD I STRUCTURE MY BUSINESS?

In Chapter 1 we covered *my* rationale for naming my business as I did and (not) preparing a formal business plan; other, more far-reaching considerations involve those decisions to be made in connection with how the business enterprise is to be legally structured. If you're asking yourself why you need to legally structure your business at all, you may not be ready to run one. Suffice it to say that because there are tax and liability consequences in any business endeavor, you *must* choose a business structure that works best for your needs. Basically, you have three legal options to choose from. Each has ramifications with regard to your specific financial situation, your tolerance for risk exposure, and your needs relating to short- and long-term planning. Here's a simplified overview of each of the three basic types of domestic (U.S.) business structures.

DBAs

A "Doing Business As" (DBA) registration is a simple, informal business structure that grants sole proprietors the right to conduct business under a trade name. Operating as a DBA allows you to open a business bank account and legally conduct your business under a business name; in addition, your start-up, management, and maintenance costs are minimal. The greatest disadvantage is that you're personally liable for

all debts the business incurs. Also, any revenue from your business is taxable as personal income.

Corporations

Corporations are generally viewed as the gold standard for structuring a business. They provide a high level of personal liability protection and make it easier for you to raise capital and obtain credit. In addition, corporations offer self-employment tax advantages and the ability to provide for medical and retirement planning. There are two distinct types of domestic corporate structures: "C" and "S." The basic differences between the two is that a C corporation can spread the profits between the owners and the corporation itself in order to lower the effective tax rate, while with S corporations, income and/or loss is passed directly to the shareholders. Other differences concern the number of shareholders each corporate structure can have. Both require that shareholders hold formal meetings, record minutes of those meetings, and file annual reports.

LLCs and LLPs

Having the characteristics of both a corporation and a partnership, Limited Liability Corporations (LLCs) and Limited Liability Partnerships (LLPs) have become the legal entities of choice for many start-ups and professional consultancies. They're easy to set up and maintain, they provide the same personal liability protection as a corporation but with fewer

requirements, and income and losses can be passed through to members as they would be in a sole proprietorship or partnership.

My recommendation would be to talk to a professional adviser—a lawyer and/or tax accountant—before deciding on any one type of legal structure for your firm. However, if you feel confident enough in your abilities to initiate the process without professional guidance, you can try an online legal service. I've used LegalZoom recently to set up another entity that I started and found its service to be hassle-free, easy to use, and affordable.

BOOKKEEPING
Why some things are better left to others

Aside from the initial set-up and subsequent breakup of my partnership decades ago plus the three name changes I've made over the intervening years, I can honestly say that I've had no further need for legal representation in some four decades of conducting business. Having a CPA to represent the firm, however, is another thing. Unless you have the head and the time to be weighed down (that's how it feels for me, at least) with monthly filings and often complex interim reporting schedules for local, state, and federal agencies, you'd better have a qualified accountant in your corner. While government paperwork may not be rocket science to understand or complete, it definitely *is* time consuming.

To me, that time is counterproductive when there is other work I could be—and probably should be—doing. Late filing? Oops! Government agencies don't want excuses, they want late fees (which accrue, by the way, and could put you on a watch list). My advice? Hook up with a CPA at the onset of your business venture. An accountant can advise you on structural issues, procedures, and regulations specific to your state, help you set up your books and schedules, keep your business in compliance, and generally help you stay out of trouble. Plus, should problems arise with governmental agencies (think audit), the CPA is there to represent your best interests. The firm we use also handles my personal tax issues and filings for a single inclusive, negotiated fee.

Since we're on the topic of tax issues, this may be a good time to touch on the matter of sales tax requirements as they apply to designers—a subject that, because many gray areas seem to exist, can lead to interpretation, even by tax professionals, and interpretation can be a sure trigger for a tax audit.

Happily (well, as happily as can be when discussing tax laws), the answers to some of the questions most frequently asked by design entrepreneurs regarding sales tax issues have been synthesized in a detailed report published by the American Institute of Graphic Arts (AIGA; www.aiga.org). I suggest you consult your own accountant, your local tax authority, or a regional chapter of AIGA for enlightenment

on how and when to charge sales tax so that you stay in compliance and out of trouble.

Back to bookkeeping: The system I use to enter and track all of the various elements that make my firm run smoothly (and make my accountant's job easier) consists of a lot more than simply posting ledger entries; it addresses every facet of business "paperwork," from initial job entry postings to time management, accounts payable, and collecting on money I'm owed. It's a simple, accurate, effective system that has served me well over the course of my career. Proprietary forms that I've developed for these and other areas will be found throughout this book for you to use as models in crafting your own internal documents.

LOCATION, LOCATION, LOCATION?
Not so much anymore

Aside from a very brief period at the beginning of my career, I've always opted for running my business out of commercial office space in midtown Manhattan. The reasons always seemed to make good business sense. Aside from having access to vital studio services, it was a given that a centralized business address communicated the level of credibility and professionalism that I believed I needed to convey in order to assure clients, vendors, and employees that I was running a bona fide business operation.

While it's still true that having a business address bestows

an added layer of prestige (and probably influence) to your business, many of the reasons for signing an expensive lease are no longer viable. Why? Because:

- Businesses in general have become more decentralized.
- Home office operations are far more acceptable than they once had been.
- Services once vital to business operations have largely been usurped by software.
- In reality, clients rarely have the need or desire to visit you.
- Rents and leases allocate too large a portion of working capital.
- "Business centers" offer an inexpensive, centralized location in which to meet clients and prospects (and, if desired, can serve as your business and/or mailing address).

The four reasons that I see for *not* working from a home office are:

1. Unwanted/unneeded distractions (such as kids, television, and of course, the fridge)
2. Communicating a negative impression to clients and prospects to whom a business address still imparts a requisite comfort level
3. Being excluded from the social and business interactions of an office environment

4. The inability to attract qualified personnel to your location as your firm continues to grow

You'll have to decide which type of business location works best for you based on your needs, your goals, and your budget. Should you decide that setting up your firm in a bona fide business location outweighs the advantages of working from home, I offer this piece of advice to ease both your financial burden and your workload: Sublet a portion of your office to a compatible freelancer. I've always taken that route and it's been worthwhile in offsetting my rent, having someone to provide feedback and assist me in lightening my workload, and having a presence in the office when clients or prospects visit.

VENDORS
Strategic alliances you can't grow without

To me, maintaining a close, productive relationship with vendors is critical to running an efficient operation. I depend on the vendors I use to be part of my "team" by having them partner with me on their portion of whatever project it is I tap them for.

By "partnering," I mean that:

- I consult with the vendors on the best ways of approaching project assignments involving their services.

- I work with them on pricing to ensure that we're both able to realize a fair profit on the work for which they've been contracted.
- I ensure that we're on the same page with regard to the quality of services that they're being engaged to provide and the scheduling they'll be required to accommodate.

When necessary, I take vendor partnering a step further by having key players accompany me to client meetings if they're able to offer guidance in specialty areas in which I may be weak. In return for the services they provide, I make certain that they're treated fairly and paid promptly. Establishing and maintaining excellent credit with vendors is essential to ensuring that they'll be there for you when you need them.

THE LOWDOWN ON MARKUPS

My general markup of 15 percent on managed services up to $5,000 covers the administration and handling oversight that I provide. Generally, that markup is buried within my proposals; there's simply no need for clients to know (or for that matter care) about markups as long as the price that's been agreed upon meets both their budget and delivery benchmarks. If on rare occasion clients balk at cost, and I'm either unable or unwilling to renegotiate pricing, I tell them that they're free to contract directly with any vendor of *their*

choosing—with the caveat that in doing so, the responsibility for ensuring quality and delivery standards will lie directly with them. The result is that in most instances, they agree to stay with the vendor I've subcontracted.

Because rigidity in pricing can often spell real trouble, especially insofar as long-term relationships are concerned, I'll often ask vendors for some wiggle room that I can pass along to the client. I've found that very few things—whether in everyday life or in business—are nonnegotiable. On the business side, this is especially true if I have a history with a particular resource or if there's a promise of future business for new suppliers.

YOU'RE NOT ALONE
Tales and tips from other creatives

Inevitably, several of the creative and production resources that I'd come to depend on over the years have since fallen victim to the times. Propelled by ever-changing computer software, intense competition both here and abroad, and a hard-hit economy, businesses that were once vital to supporting the graphic design industry have since been relegated to second-tier status—or worse, extinction.

The Macintosh computer, of course, has just about eliminated the typography industry, once a mainstay resource for any design firm. The same holds true of photostat houses, traditional retouchers, photo services, and art supply stores,

to cite but a few examples. Printers have suffered significantly from what seems to be a perfect storm of confluences: the high cost of equipment, overhead, and operation; constant advances in digital printing; the globalization of competition; a weak economy; reduced budgets; and the fact that more businesses than ever are opting for an online-only presence (my personal thoughts on this last subject are voiced in Chapter 4). For those of us "seasoned" enough to have once depended on these services (and the commissions they brought), their demise is really kind of hard to take.

Closer to home, some of the other essential resources that design firms like mine have come to depend on seem to have fared only slightly better. Unlike typographers and printers—vendors who fall loosely under a "manufacturing" label—the creative services I'm talking about include photographers, illustrators, copywriters, and marketing consultants, that brotherhood of small, independent businesspeople whose livelihood is dependent on a constant work flow from designers and others in the communications industry.

Because of the significance of this tight-knit creative alliance, I've asked a few of the resources with whom I've partnered over the years to provide some insights into the working relationships they've encountered with their clients, and to relate some of the issues they've faced in trying to keep *their* businesses afloat. Each of these entrepreneurs boasts more than three decades of practical business experience. I think you'll find that having a clearer understand-

ing of how they've managed to cope with business matters will help you better appreciate the commonality of the issues we'll all face at some point.

The first of these entrepreneurs, Nancy A. Shenker, was a marketing manager and my primary contact at Citibank at a time when it was by far my most important client. Today Nancy runs two businesses aimed at helping start-ups with marketing and business-building strategies. Here's her advice:

> Hire or engage the other half of your brain. If you cringe or shudder whenever you see the word "QuickBooks" or glance at an Excel spreadsheet, you need to make sure that you have a trustworthy, experienced, and reliable person working with you to help you with your day-to-day billing and collections. My search for the "perfect" bookkeeper took close to five years and cost me thousands of dollars over time. Remember, even if you have a financial superstar working with you, YOU as the business owner need to review your cash flow and P&L regularly and deal with any problems or questions *immediately*.

> Speaking of management oversight and involvement, it's no secret that we all hate to deal with difficult people issues. But when times are tough or we lose a big account, we may be put into a position where we have to let someone go, downsize office space, or cut back on

"perks." Act quickly and fearlessly when you are forced to make these decisions. When the recession hit, I was still a relatively new business owner. I allowed my heart to override my head and my balance sheet at times and waited to make cuts, hoping that business would "turn around soon." Those of us who have hands-on capabilities are actually the best equipped to handle downturns, because we can operate lean and do work ourselves until the dark cloud lifts.

Especially in our era of social media and brand ubiquity, knowing what makes your business unique and ensuring your company is easily found is more important than ever before. All too often, I've seen graphic design and marketing firms with poorly written websites, no social media presence, or typos in their materials. "Shoemaker's children!" we cry in despair. We've all been there. Even if you can't afford a bells-and-whistles website or have limited time for social media, your USP (Unique Selling Proposition) should be clear and compelling throughout all your communications. In all our proposals, we include a page titled, "What Makes Us Different from 'The Other Guys.'" Look at your company through the eyes of the prospective client. Would *you* hire yourself based on your online presence?"

Ed Haas is a talented, levelheaded photographer (believe me, being levelheaded is an important attribute; I've worked

with many creatives who aren't) with whom I first collabo-
rated when I was designing corporate and marketing com-
munications materials for the Girl Scouts. Here's what Ed
has to say about his career choice:

> After thirty-four years in the business of being a self-
> employed photographer, I have yet to find a way to
> comfortably deal with the ups and downs of the busi-
> ness. On the balance sheet I have been successful, but
> the feast-or-famine lifestyle has turned my hair gray,
> had my family question my sanity, and has seen me
> tackle all the tasks of a corporation wrapped into one
> person. If I had known then that I'd still be doing this
> today I would have consumed much less Alka-Seltzer.
> I started my business in 1977 as a photographer. Little
> did I know then that I was also taking on the roles of
> salesperson, accountant, inventory clerk, messenger,
> and janitor. I had been taking pictures for college photo
> classes, living the esoteric lifestyle of an artist until the
> day I was hired as an assistant by a corporate photog-
> rapher with an ex-military background. He was a no-
> nonsense shooter who, within a week, upended all the
> concepts I had about being a pro. I learned that actual
> picture taking was only half of the business of being
> a professional photographer. Bringing in the work was
> the other half. A crash course in sales and marketing
> was the first task at hand. They don't teach these things

in photo class. It was "sink or swim" if I wanted to have a business to run.

After a few years, I established a number of regular clients and life was good. Too good, it seems; one day I got the dreaded phone call. My best client told me he had taken a new job that no longer needed photography. He said he'd "pass my name on" to the new person who, naturally, had a friend who was a photographer. I was toast. That initiation into the real world of the photo business set the tone for the entire length of my career. It's a given you'll lose clients for reasons other than the quality of your work, but how you go about replacing clients or building on the ones you have is as integral to the business as knowing how to light a portrait.

Since I began my business, the game has certainly changed. Back then you'd call potential clients and find out when the portfolio drop-off days were. If you were lucky and had a connection you might even get to present your portfolio in person. These days it's "do you have a website where I can see your work?" I'm lucky to have established long-term clients and have gotten much of my work from recommendations; however, there are still slow periods that come on like a tsunami and devastate me to the point where I feel I'll never work again. Normally, most people would take advantage of the slow time and go on vacation, but not me. I'd sit by the phone, waiting for the "big job" to come in.

I find that today's best method of growing my business is through networking. Any opportunity to talk to people about what you do and how you can be an asset to them is time well spent. Of course everyone is on a budget, so be ready to rationalize why you're worth your fees.

When my firm was commissioned to establish a branding platform for Travelers Insurance Group, I brought in Faith Tomases, a brand strategist I had done business with before, to team up with me on this important project. Here are some of Faith's entrepreneurial reflections on what it takes to be successful as a sole practitioner—words of wisdom that you'll come across in one form or another throughout this guide:

Keep your overhead low. It reduces the stress, particularly in slow periods.

Treat every encounter as a networking opportunity. You never know who knows someone or where a lead will come from. I've gotten projects from people whom I first met several years ago and ran into again at a camp reunion, three states away.

Remember that the person you meet today may become a potential client tomorrow.

Keeping in touch to nurture relationships is imperative. It's a lot of work, it's very time consuming, and it's certainly

not my favorite activity—but it is necessary if you hope to keep your name at the forefront of people's minds. I've gotten calls for projects years after first meeting people. There have been many times when a client has told me that they're so glad I called when I did because they have a project for me. Many more times I've heard them say that they wished I had called the week before because they had had something then; I just wasn't on their front burner at the time.

Adopt a selling style you are comfortable with and that matches your personality regardless of what business courses may teach to the contrary.

Accept the fact that there will be slow periods and use your downtime effectively. Someone gave me this advice when I first got started. I repeat it to myself often—it helps me get through the slow periods.

Pursue and work with people who are nice. There's no reason to deal with people who are unpleasant to work with. Working with people of your own choosing is one of the reasons that you probably went into business for yourself in the first place.

Everything is negotiable (although, usually, the negotiations issue from the client asking you to reduce your fees).

Consider bartering your services; it's a good way to reduce cash outlay.

Team up with someone with a related service. Doing so

enables you to offer a broader set of capabilities when pitching certain prospects.

Consider what ancillary or related services you can provide in addition to your main business in order to generate additional revenue.

I was first introduced to Gordon Andrew back when I counted the American Stock Exchange as my very first corporate client, some three decades ago. Since those early days, through good times and bad, Gordon and I have remained both friends and business collaborators. Whether as an executive employee or marketing entrepreneur, Gordon has put his vast experience to work for some of America's largest, most successful companies—and, because of our ongoing collaborative alliance, has been directly responsible for putting me together with many of my most prestigious clients. Here's Gordon's advice to entrepreneurs:

It's lonely at the top . . . What goes on inside your head will always drive what happens, or fails to happen, at your small firm. With no "boss" telling you what to do or providing feedback, the most difficult challenge for owners of small consulting firms is staying motivated. To remain focused and inspired, owners need to seek out books, videos, and audio tapes that focus on motivation, personal achievement, and success. You will need this type of third-party guidance to endure the

self-doubt and disappointment involved in running a small firm.

Stay in the game . . . Keep plugging for new business, even when times are good. Clients will always come and go, so you need to keep your sales pipeline full at all times. Avoid getting trapped in the marketing/servicing cycle, where you devote most or all of your time to either marketing prospects or servicing clients. You must balance both.

Develop a thick skin . . . You cannot take rejection personally. Many prospects will be rude, simply blow you off, or not respond to proposals that you've invested significant time on at their request. Resist the urge to send a nasty note. Circumstances can sometimes change, and they may contact you (or refer you) at some later date. Cashing a rude prospect's check is the best revenge.

Don't become a prisoner of your business . . . work ON the business, not just at the business. This means establishing systems, routines, and processes that are documented in the same way that McDonald's has made itself a turnkey business. By institutionalizing your business, it will not rely on you or on any other employee to continue and succeed. It will have intrinsic value. I suggest you read *The E-Myth* by Michael Gerber to learn more about this concept.

Keep yourself healthy and fit. You cannot be on top of your game, or be perceived as being on top of it, if you

do not look and feel well. Working long hours, it's easy for business owners to put their physical needs last. You will pay a big price for putting yourself last, in terms of energy, stamina, and creativity.

I first met Peggy Greenawalt when her firm was engaged to develop an online marketing program that I was working on for one of my clients. Like the other independent professionals who have volunteered their thoughts on these pages, Peggy has offered to share her views on how to manage a small creative business in good times and bad. Read on:

It's the same in any economy: Sales are sales. As a small creative marketing company, I'm always selling either my clients' products or services or myself.

During a tough economy, with sea changes in both technology and society, it's simply more difficult to power up. I have always done well by expecting change and trying my best to be on the leading edge of it.

Change excites me. I like learning new things. I love new technology and new media: tools that make it easier to build business for myself and for my clients.

I also like people. I respect them and their work. So it's never been hard for me to approach a new prospect if I know that client needs something. If I don't believe I can help him or her, then that's not my prospect.

It's important to make the selling process as easy as possible. The medium doesn't sell the prospect; the crafty marketing of the medium sells the prospect. That's what I do—marketing. And I'd like to think I do it better than anyone.

In this business, beware of kidding yourself that old skills are enough. Don't waste time on a difficult sale or with a difficult person. To me, success in business is working with great people who need me, enjoy working with me, and respect what I do. My formula for success is to put in more effort than my competitors are willing to do without selling myself short in the process.

Identify and contact the most promising and respected clients you can work with. Deep pockets mean you'll get paid. Remember that a satisfied client attracts more business.

Giving great service and helping a client build growth and profit is the value I bring to every assignment, but in these changing times, putting a dollar amount on that value is a tricky proposition. In today's Internet-driven economy, everyone seems to be looking for something for nothing. Companies are floundering in part because they are hiring next-to-free work from inexperienced people who charge accordingly—people who sell themselves as marketers, but have no foundation in even the basics of marketing communications.

To thrive today, it's important to realize that only the

marketplace has changed, not the tactics. Get as intimate with your target as possible. Research the client, the company, and the competition before making contact. Do your homework and know what you're talking about. And if you don't know, don't be timid about asking. You'll be respected for it.

Build a strong brand for yourself, stay flexible, and above all, expect and embrace change. And if you find that you don't love this business (or it doesn't love you), find something else to love. Life offers so many wonderful ways to thrive.

Annalee Wilson heads a small, successful design firm that mirrors mine in many ways, including our working with some of the very same clients. In fact, it was a mutual contact at one of those clients who suggested that Annalee might like to contribute some of her experiences to this book. Here's what she had to say:

> I started a graphic design consultancy with two other women in a period of feminist optimism that coincided with a huge recession. At the time, the country was broke and only 6 percent of domestic businesses were women-owned. Although I'd had five graphic design jobs in five years, graphic designers were encouraged to work for a company or agency under a good creative director, learn what they could on the job, and move on. In this way

I broadened my design experience and inadvertently picked up some core values about doing business.

After five years I realized I needed more control over my projects, so I began freelancing and informally sharing the projects with two other women friends who were out of work because of the economy. We merged our samples into one portfolio, and as soon as I showed it, received an assignment to design and illustrate 600 pages of educational material at the astounding rate of $100 a page. $60,000 was the most money I'd ever seen. The deadline was tight and the components were so numerous that in order to accomplish it, the three of us would have to form a partnership. With no capital and no business experience—just a sense of blind faith in sisterhood and our own talents and abilities—we opened our new venture.

Over the next two years the business grew, adding more publishing clients until we broke into entertainment, flooring, automotive, corporate, nonprofit, and food and medicine. So many things contributed to the early success of our company, but five things were key: our commitment to design excellence, being conservative when it comes to money, keeping our fees competitive, pitching companies that promoted women into management, and the fifth—luck. Except for pitching companies with women in management, the rest of these keys are still in force.

Today I am president of Kaeser and Wilson Design, the offspring of the original company. We've made it through seven recessions. Each economic downturn has had its own fingerprints, so I've employed different tactics to get through. Lately, as I watched so many clients and friends lose their jobs, I began to think about how much talent was going to waste. It gave me the idea of forming collaborations to pitch clients in need of our combined services as a way of helping this underutilized talent pool make money in these tough times. Happily, this strategy has been successful, as I've been able to forge several working relationships that have led to new and satisfied clients.

My relationship with photographers and illustrators has been replaced by clicking through online stock libraries. Visual elements that were once under my design control are now under the control of the computer that receives them. The tools of our trade have changed. The dexterity needed for the job is no longer the same, but the basic business challenges remain: How to find and retain customers that value our ideas, and how to get paid fairly for them.

As you've no doubt noticed in reading these accounts, circumstances may differ to one degree or another from person to person but there remains a thread of continuity among each of these contributors' narratives, regardless of

the particular career path they've chosen. What you can take away from these accounts is this: As small-business entrepreneurs in the creative field, each of us has encountered many of the same issues that you undoubtedly have (or soon will) and have found ways to manage adversity and build on success regardless of circumstances.

Always remember to:

- Keep a positive outlook.
- Believe in yourself.
- Confront your weaknesses objectively.
- Build on your strengths.
- Treat your business as a business.
- Approach design from a marketing perspective.
- Network at every opportunity.

3

DESIGN FIRM MANAGEMENT

Tools and templates

MANAGING BIG-BUDGET COSTS

While I generally have no problem with the majority of third-party expenses being billed directly to my account, there are times when, for obvious reasons, I really don't want to bear the possible financial liability that comes with some big-budget items: the printing of an annual report, for example, or the fabrication and installation of a signage program that runs to amounts I don't want to be held responsible for. I do, however, still want to make my commission on these items.

The forms in this chapter are available for download at www.amacombooks
.org/go/GraphDesign.

In such instances, I've established two ways of addressing this issue:

- The first is to build commission (or markup) amounts directly into my estimates as additional time and then have the vendor bill the client directly in the actual amount that was quoted and approved.
- The second is to break out the vendor's quoted price to my client as a component of my estimate, building in my sliding-scale markup (i.e., 15 percent on costs up to $4,999; 10 percent on cost estimates from $5,000 to $10,000; and 5 percent on costs over $10,000) and submitting it for approval with the understanding that the vendor will bill my client directly at the quoted amount. After the job is completed, the vendor bills my client and I bill the vendor for the markup difference. Once he gets paid, he cuts me a check in the amount of the markup.

Obviously, in either instance, the client must authorize this arrangement and agree to be accountable directly to the vendor for the costs involved. Similarly, the vendor must agree to bill my client directly in the amount I had quoted. A paragraph contained in the expanded version of my work agreement addresses this issue for the client:

Indemnification

You agree to assume final responsibility for proofing of all copy, content, and manufacture as may apply, and to indemnify us against any damages, costs, or losses that may be suffered as a result of any claim arising out of the services performed or materials prepared by us in connection with this assignment. Purchases of printing, fabrication, and/or other major production expenses may be invoiced directly to you from the vendor(s) subcontracted by us. In such instance(s), payment will be subject to each vendor's policies.

We make no warranties with regard to any third-party suppliers.

THE PRINT PRODUCTION SPECSHEET

I've found that the best way to ensure that quotes from different printers can be compared "apples-to-apples" and accurately reflect my wishes is to submit a comprehensive breakout of the specifications and conditions required for the project in question. The print production specsheet (and when possible, a sketch or mock-up of the intended project) gives each vendor a concise picture of how I envision the final job. The specsheet (see Figure 3-1) also offers the vendor an

DanielsDesign

Print Production

☐ Quote Request ☐ Client Confirmation ☐ Work Order

To

Date

Project ID

Quantity

Size

Page count

Process

Art

Color

Halftones

Cover

Text

Other

Proofing

Special
Instructions

Bindery

Delivery

Notes:

Vendor Note *Please return this form or your own with your estimate and proposed scheduling clearly indicated.*
Any caveats to these specifications must be noted. DanielsDesign does not honor charges for overruns.
Be certain to identify your company and provide a contact when submitting your quote. Thank you.

FIGURE 3-1 Print Production Specsheet

opportunity to suggest modifications on ways to possibly make the project less costly, meet scheduling requirements more quickly, and/or make the final product better and/or less expensive in some way (and speaking of keeping the lid on expenses, note that I refuse to pay for after-completion add-ons such as overrun charges). This document also provides me with an instant, accurate record of all job specifications, which is an invaluable reference for reprints or updates down the road. Once the quote has been approved, the final specsheet, if required, is modified to reflect any changes and is resubmitted to the vendor as a work order.

CASHING IN ON MEDIA COMMISSIONS

I may catch some flak for saying this, but serving as a client's ad agency no longer seems to require affiliation with the 4A's (American Association of Advertising Agencies), as was once the case. In my own experience, consumer and trade publications are only too happy to give any firm representing a paying client the standard 15 percent media commission that agencies are entitled to, assuming you're able to demonstrate the means to pay for the advertising you're purchasing on behalf of your client. In the case of major media outlets, you can expect to undergo a more thorough vetting process before they'll recognize you as a bona fide agency, but assuming you make it through, and assuming you have clients who want you to place advertising for them, serving

as their ad agency can be extremely profitable (not to mention extremely expensive and therefore potentially volatile for you). The key is to reduce or eliminate your financial risk as much as possible. Here are two examples of how I've handled this element of the business mix:

1. The Campaign. My foray into serving as an ad agency began when I suggested to one of my clients, a law firm, that its members might want to consider the benefits of media advertising, something they had thought about in passing from time to time, but had never acted upon. In order to offer a compelling rationale for my reasoning, I put together a presentation consisting of competitors' display ads along with some of the numbers and demographics culled from media kits that had been gladly supplied by the legal publications I contacted. That demonstration led to my firm being engaged to prepare a series of prototype ads for management consideration. The ad mock-ups we prepared were presented both as a stand-alone series and also pasted into the pages of the publications I had recommended. In short order I was given a green light to run some test ads. As of this writing, some six years after those first ads ran, the series of half-page, full-color display advertisements for this firm continue to appear monthly in one or more law journals.

Toward the end of each contract year, I prepare a comprehensive report citing the past year's activity as it relates

to the objectives that had been established when the campaign was first endorsed. The report also contains comparisons with competitors' advertising and recommendations for linking upcoming ads to corresponding editorial content and events. Much of the rate and demographic information you'll need to include in the report can readily be harvested (or reproduced directly) from the media kits that the various publications compile.

As soon as final recommendations for the upcoming year are endorsed, I prepare a contract covering that period. Invoicing for each apportioned ad in the series is mailed approximately one month prior to the actual publication date, ensuring that the gross cost of the advertising (plus any corresponding incidentals such as rights-managed photography) has cleared my bank account and is available to pay the net amount to the publication as soon as I receive the invoice.

2. The Announcement. When I was asked by another client to prepare both print and media announcements publicizing the opening of a new regional office, I was charged with buying space in the national edition of the *Wall Street Journal,* the regional *Boston Globe,* and two nationwide trade publications. The aggregate cost of running these one-time insertions topped the six-figure mark—way too rich for my comfort level but with a commission amount that I just couldn't see turning down or sharing (a com-

mon practice whereby small firms that have neither the credentials nor the desire to directly place advertising of this scope contract with larger agencies or media-buying services to place the advertising for them and then split the resulting commissions).

Rather than resorting to a split, and with the client's approval, I pre-billed the gross amount of the advertising far enough in advance of the insertion dates to ensure that I'd be able to write and cover net payments to the various publications involved as soon as they became due. A word of caution here: If your client balks at fronting the cost of the advertising, treat it as a red flag; the very last thing you want is to be left holding the bag for a large advertising bill.

As I always have, I'm certain you'll find the personnel at the various media sources to be extremely helpful—both in supplying you with all of the facts and figures you'll need to prepare comparative data for your clients, and in working with you to ensure that you get the full commissionable amounts you're entitled to.

Ad buys are detailed in insertion orders that are first prepared for the client to approve, citing only the gross amount of the buy(s), and then edited for the publication, showing both gross and net amounts (see Figure 3-2).

DanielsDesign

Insertion Order

☐ New ☐ Extension ☐ Make Good ☐ Cancellation

Project ID

Date

To

Please publish advertising of

Edition/Section/Feature

Number of insertions covered by this order

Issue(s) / ad tag

Space

Color

Position

Artwork

Amount due pub Net $ Gross $

Authorized by:

Billing is expected concurrent with publication dates. Tear sheets must accompany invoice.
Publication must provide ample separation from competitor advertising.

FIGURE 3-2 Insertion Order Template

TRACKING SALES EFFORTS

In order to be able to quickly relate to past communications, I keep running logs on each prospect I solicit, citing the dates of contact (or even contact attempts), along with a brief summary of any exchanges that may have taken place, whether by phone, email, or snail mail. I also log call-back and/or reconnect dates and times on my computer and set them up to alert me when scheduled. Figure 3-3 provides an example of my system. I find this to be a valuable reference tool for follow-ups, and I know that you will too, one that will keep you current and generally impress prospects with your ability to recall the minutiae of previous contacts.

ASSIGNING PROJECT IDENTIFICATION
The key to efficient administration

Each new client is assigned a two- or three-letter abbreviation code that allows easy recall and permanent identification. As an example, "Amalgamated Industries" might be assigned the company code "AI" followed by the number 101. Subsequent project assignments for that client would then be identified by adding sequentially to that number (AI102, 103, etc.). In the case of phased projects, a dash followed by the number two, three, and so on (i.e. AI101-2) would be attached to the original project number until billing for that particular project or phase is complete. By segmenting proj-

DanielsDesign

Sales Contact Tracking Log Year_____ Sheet number_____

Company _____

Address _____

City/ST/Zip _____

Main phone (_____) _____

Main website _____

Contact _____

Title _____

Direct phone (_____) _____

Email _____

Date Action

_____ _____
_____ _____
_____ _____
_____ _____
_____ _____
_____ _____
_____ _____
_____ _____
_____ _____
_____ _____
_____ _____
_____ _____
_____ _____
_____ _____
_____ _____
_____ _____
_____ _____

FIGURE 3-3 Sales Contact Tracking Log

ect steps in this way, corresponding time and expenses can be quickly and accurately matched and broken out for progressive billing, which is discussed later in this chapter.

TIME TRACKING
The key to managing profit

Tracking your time plus the time of others under your direction is, of course, your primary means of assessing profitability. If you bill directly from time sheets, the likelihood is that you're still being regarded as a freelancer; if, on the other hand, you bill from a previously authorized proposal that you'd submitted, it's a safe bet that you had estimated time requirements both for yourself and others under your direction. Keeping an accurate accounting of time on *every* job not only determines profit or loss on any given project, but also serves as an invaluable guide for estimating new work of the same nature going forward.

Time management discussions and forms are covered more thoroughly in Chapter 8.

THE LEDGER
Documenting and tracking receivables

Your ledger will provide you and your accountant with an overall snapshot of when billing was sent, to whom it was sent, the amount billed, the amount of sales tax charged, and

when the invoice was paid in full or in part. Whether you decide to post your billing electronically or manually, your ledger entries should track, in order, the following entries:

- Invoice date
- Client name
- Net invoice amount
- Sales tax (and rate)
- Gross invoice amount
- Amount and date of interim (or on account) payment(s)
- Amount and date of payment in full
- Project identification number
- Invoice number
- Brief project description

Make certain that you obtain and keep current tax exemption certificates from clients who claim this exclusion. Remember too that only the end user is liable for paying tax on work you've undertaken. Make sure that you obtain a resale certificate that will allow you to pass that liability on to your client.

INVOICING
Structuring how you get paid

Back when I started my business, I assigned my first invoice the number "1001" and have added sequentially to that num-

ber ever since. I find that it's a simple, accurate way to record and track billing. This numbering system makes it easy to quickly recall invoicing as needed by cross-referencing the ledger or client files.

New invoicing for repeat clients is accomplished simply by plugging in whatever current information is needed (i.e., invoice date, project number, purchase order number if applicable, project name, period covered, description of work performed, amount(s), subtotal, tax due, and total) on previous invoicing. I save each invoice electronically by job number, in PDF format, and then email the file to the client (with a hard copy going to the filed job folder). Many other designers I know prefer to use a year/number system, that is, the current year followed by a three- or four-digit number beginning with the number one and then continuing on sequentially (i.e., 2012-001, 2012-002, and so on). I prefer my method if only for the sake of perception; I'd rather not have the client able to figure out just how much—or how little—business I've done for the year up to that point.

MANAGING CASH FLOW

Maintaining positive cash flow is, of course, critical to meeting payroll (even if it's only for you), rent, tax obligations, marketing budgets, and supplies, and generally keeping your business afloat and moving forward. Trouble is, in small service businesses like ours, maintaining a steady cash flow can

often be more of a dream scenario than a reality. A more likely course of events often involves roller-coaster months, slow payers, and occasional write-offs for bad debt. So how exactly can a small design firm cope with a mix of spotty income and regular, ongoing expenses?

Like all graphic designers, I've always taken a great deal of pride in the creativity that I bring to each and every assignment entrusted to me. The thought of relegating design to someone else used to strike me as antithetical to what my clients were hiring me to do—that is, until I finally came to realize the no-growth the futility of a cycle that would never allow me to break out of the pitch/work/repeat model that ruled my life, my income potential, and my cash flow. And so, once I felt secure enough, both financially and emotionally, to "let go," I came to discover that outsourcing the design and production functions of my business was the real key to taking it to the next level.

While outsourcing may seem like an extremely counterproductive move bordering on blasphemy for a designer, the truth is that establishing strategic alliances with one or more talented freelancers has proved to have many benefits for me. For one thing, it enables me to work with a caliber of professionals that I could not otherwise afford to hire on a full-time basis; second, it frees me from the expense of having to invest in new hardware and software, or in the time-consuming learning curve often required to master new programs or new versions of older ones; and finally, it

affords me the opportunity to pay only for billable uptime—no salaries, and no medical, pension, or profit-sharing plans to deal with. I still direct creative output, but with none of the overhead or emotional headaches or heartaches (think hiring, firing, annual salary negotiations, bonuses, and, of course, personality conflicts) that are part and parcel of permanent staffing. Perhaps best of all, this arrangement gives me the "breathing room" I need to grow my business by granting me the time I need to properly service current clients and to engage in meaningful new-business prospecting.

You may be thinking that hiring a freelancer to do the work that you've been contracted to deliver is somehow "cheating." Well, here's a news flash—it isn't. As I already stated, you're still the one calling the creative shots; plus, since designing in a vacuum is a sure recipe for stagnation, you'll have the benefit of another opinion if you want one. The other argument I've heard against paying a freelancer is that it effectively reduces your income. That's the kind of logic that will stop any potential business growth dead in its tracks. Start thinking like an entrepreneur and stop worrying about short-term circumstances. Remember the old adage: "You have to spend money to make money."

There *is*, however, one significant downside to engaging freelancers; in order for them to survive, they have to service their other clients too, and therefore cannot always be expected to be there for you when you need them. That's why

I maintain relationships with at least two design resources, each with compatible talent levels, hardware, and software. This arrangement also allows me to occupy smaller, less expensive workspace and greatly reduce other costs, such as equipment and supplies.

As you may recall my saying back when we were talking about location (Chapter 2), if you *do* have the space available, consider subletting it to one or more of the freelancers you work with. Not only will such an arrangement create another income stream for you, but better still, having people on premises will both (a) reduce errors and miscommunications that invariably occur when parties are separated, and (b) aid in projecting the appearance of actually having your firm staffed. If you're concerned that being less than truthful on this last point will somehow damage your reputation in some way, believe me, it won't. It's a perfectly acceptable practice that in fact provides a much-needed comfort level to both you and your client or prospect.

A good analogy to this situation can be found in the original *Mission Impossible* television series. You may recall that once Jim Phelps had an assignment in hand, he would scan his book of operatives, choosing those best suited for that particular job. Similarly, when asked to bid on a project requiring skill sets that are beyond my capabilities, instead of turning down the assignment, I secure the services of trusted professionals to provide the support I'll need. To make the prospect or client aware of the talent I intend to

bring to the project, I'll often attach a page to my proposal citing each player's accomplishments.

PROGRESSIVE BILLING
The key to staying solvent

The key to ensuring a steady cash flow—beyond the obvious strategy of bringing in more business—is to bill progressively. I've addressed that issue within the terms of my understanding with clients; you may find it useful to adapt to your own agreement:

DanielsDesign fees are estimated on a descending rate scale commensurate with anticipated time requirements and functions necessary to complete this assignment.

This proposal is based on our current understanding of the project as described herein. Included edit rounds are deemed to be reasonable and customary; additional edits are chargeable at prevailing studio rates. Sales tax will be added as required by law. Invoices are issued at the conclusion of each work phase or progressively at the end of each 30-day period, whichever comes first. Terms are net 30 days with a service charge of 1.5% added to the unpaid balance.

4

DESIGNING
A RELEVANT
FIRM IMAGE

FOCUSING ON A DEFINED PRACTICE AREA

I recall an interview I was sent out on at the very beginning
of my career. The art director looked over the typical over-
load of work in my book—mostly student portfolio pieces—
stopping occasionally to ask which component of the sample
in hand I had specifically worked on. The illustration? Yes.
The typography? Yup. The photography? Uh-huh. The lay-
out? Of course. Finally he asked, simply and directly, what
area of this business I intended to pursue. It was an eye-
opening question for me; until that moment, I had assumed

that each element of the design process loosely fell under the heading of "graphic design."

Each subsequent twist and turn in my professional evolution—from designing book jackets to developing corporate identities—has helped to guide my present niche. The descriptor on my business card, *"Branding and Integrated Communications Design,"* ultimately provided the track that I was seeking in a boutique business enterprise in terms of creative satisfaction, client interaction, prestige, and firm profitability. Although you may be able to do it all, I would strongly suggest that as you evolve professionally, you evaluate your greatest strengths and focus them within a more narrowly defined practice area. Concentrating on a specialty also imparts the credibility and comfort level that clients and prospects look for in a creative resource.

DEFINING YOUR USP

Your unique selling proposition (or USP) is essentially a brief encapsulation of that single attribute that differentiates your business from that of your competitors in a memorable way. Taglines are often the vehicle of choice for attempting to establish and drive home this clear point of difference between competing products, services, and brands.

Will a catchy tagline help to define your firm? Probably not. Applied to a professional consulting service, a tagline can seem presumptuous and totally out of character. Still,

because the need to draw a distinction between your firm and others in a meaningful and appropriate way will likely play a defining role in shaping the way your firm will be perceived, it's probably a smart idea for you to establish some form of USP.

And so the question becomes, how do you go about the task of defining a role for yourself that doesn't ring hollow? Well, to begin with, it's important to understand three fundamentals about your competitors and your target audience.

First, recognize that there are a lot of good designers out there in the same situation you're in. Second, understand that in this industry in particular, a disproportionate number of potential competitors will set themselves up in business, just as you've done. And third, regardless of how solid you think your relationships are, always assume that your competitors are vying for your clients' business.

With that understanding, the issue then is not necessarily how good you are as a designer, but rather, how good you are at being able to establish and communicate *a point of difference* that will resonate with clients and prospects and in turn provide you with a unique and exploitable marketing platform.

My counsel is to assess your strengths realistically, taking care not to oversell your capabilities. Find that single point of difference that makes you more valuable in the eyes of your target audience. In my own case, once I grasped the impact of being invited to compete—often successfully—

against much larger design firms for a share of prestigious business, that became a huge selling point for me, one that I express regularly, if not verbatim, as my USP in nearly every sales letter I send out. Take a look:

DanielsDesign is a highly regarded branding and communications design firm delivering an unmatched balance of critical thinking and practical problem solving in the planning and development of important corporate and marketing communications tools and programs. With a practiced understanding of the power of perception, we're able to identify, develop, and position targeted, integrated messaging that speaks with clarity, credibility, and memorability—without the overhead or management layers often found in larger branding firms.

The first part of that message is intended to separate my firm from the pack; to have prospects cognitively rank DanielsDesign as a top-tier design firm. The last part informs them that (a) we're less expensive than our competition and (b) they can expect to deal directly with a firm principal. In short, my USP is intended to ensure prospective clients that they'll receive the same quality of analytical thinking and applied creativity as they would get from the "big boys" without spending nearly as much or having their assignment relegated to a junior designer.

Whatever area of design expertise you intend to focus on, just remember that it's important to craft sales messaging that encapsulates your *primary strength* effectively and exploits it consistently. Once you get that proverbial foot in the door and have had the opportunity to demonstrate your value to your client, you should find that it's relatively easy to expand on your other capabilities.

DESIGNING FOR BUSINESS

In my long experience, I've found that too many graphic designers approach assignments primarily from an aesthetic viewpoint, with little regard to solving the client's core communication problem. While in certain areas of the graphic design spectrum this approach may be perfectly acceptable, to me, problem solving by design means:

- Gaining an in-depth understanding of each client's particular business focus and culture
- Being able to assess a client's strengths and vulnerabilities in the marketplace
- Counseling change only as it may be required in order to meet clearly defined corporate and marketing objectives
- Implementing recommendations in a realistic, manageable, cost-effective way

- Being able to articulate the value of design in achieving attainable business goals
- Establishing appropriate design parameters for creating brand-integrated tools and programs intended to reinforce a desired perception
- And always, *always,* looking at problems to be solved through design from the perspective of the client's intended audience

Whatever area of this business you intend to focus on, my advice would be to view your role not simply as a design resource, but also as a consultant to your client by being able to provide sound, practical marketing advice that will position you as a "first call" creative resource.

SHOWCASING YOUR QUALIFICATIONS

Because your primary selling tool is the work you've created for others, it goes without saying that that work needs to be showcased properly if it is to serve you effectively. Over time, I've developed an ordered, professional presentation approach that I want to share with you.

Although I retain samples of all of the jobs we've completed, I showcase only those that will serve to reinforce the design capabilities that I want to project. Samples are staged and photographed in simple, complementary settings. With an available catalog of project images to choose from, I'm

then able to tailor a presentation to the perceived needs of each prospect I pitch. This approach gives me an undeniable edge over my competition by demonstrating my firm's focused experience within the bounds of each prospect's business sector. The presentation strategy I've used successfully is a three-part mix consisting of both my website and an in-person portfolio display.

Let's look at each of these in turn as they may apply to you.

Your Website

There are two core building blocks to "brochure" (as opposed to e-commerce) website development: design and content. The first reflects; the other informs. Unless these two components are in balance, it's likely that your website will do you more harm than good as a practical selling tool.

Since it goes without saying that your website will be viewed as an overall barometer of your design capabilities, keeping it clean and compelling is essential to effectively communicating the level of professionalism you hope to project. My advice as you design (or refresh) your site would be to keep repeating the mantra *Less Is More* to yourself. Remember that site design should always complement—never overpower—your work product. Along with ensuing ease of navigation, it's important to keep Flash animation, color, mixed font usage, and any other potential distractions in check.

Content begins by limiting the number of sections your site contains. To see things in perspective, critique some other sites—especially those of well-established, highly regarded firms offering the same range of services that you provide—viewing them objectively, as if you were a potential client. Keep in mind that your target audience will likely skim over much of what they consider to be self-serving babble, just as you probably will. A good rule of thumb is to limit site content to no more than three fundamental sections:

The capabilities page should outline the rationale for using your services. If, like mine, your goal is to convey the competencies of a larger firm together with the personal interactions of a single practitioner, you have to try to find a way to communicate that position without sounding like every other designer who strives to project those very same attributes.

The bio page should obviously outline your qualifications—but only by referencing professional achievements (awards received, articles published, your problem-solving approach, professional affiliations, etc.). Only educators, doctors, scientists, and lawyers gain any notable advantage by listing educational credentials. For a designer, mentioning schooling only serves to diminish the perceived seniority of your experience level. It's also a fairly common practice to post the bios of those

independent contractors with whom you work with on a regular basis (with their permission, of course). Doing so reinforces the perception of the size of your firm and the scope of services you provide (i.e., copywriter, photographer, brand strategist, etc.).

The portfolio pages are, of course, your core selling tools. I've found that a "common problem / uncommon solution" approach works best in telling a compelling story that prospects can relate to. As I mentioned earlier, project samples should be photographed simply yet dramatically and supported by brief, descriptive copy that's broad enough in scope and convincing enough in narrative to resonate with your audience.

My advice here is to simply state the problem you were engaged to solve and briefly describe how and why the solution you came up with worked for your client. A great way to boost credibility for your solution would be to include a client testimonial along with the project(s) you're profiling. Because third-party endorsements are presumed to be unsolicited, they make for exceptionally strong marketing tools.

I try to limit my website project profiles to no more than about a half dozen showcases that I had created for different clients in different trades, with each solution emphasizing a unique approach to a not-so-unique corporate or marketing communications problem. Highlighting design-based solu-

tions that are germane to a broad segment of industry helps the viewer to connect your expertise to a problem that he or she may also be encountering.

Unlike many designers, I don't categorize my work by genres such as "logos," "booklets," "ads," "websites," etc. (although I do list links to some of the sites we've designed), because each of the samples I choose to highlight generally contains elements of one or more of these categories within the overall context of the piece anyway. If you'd prefer to go that other, more typical route, my recommendation is to make certain that the samples you select to show will clearly relate a design *solution* rather than simply demonstrate your design *ability*.

Your Portfolio

Your portfolio presentation, on the other hand, should be far more *adaptable* to your audience than your website is. Think of your website as an introduction to your capabilities, and your in-person presentation as a next-level, more prospect-centric selling tool—one that stands to either enhance or diminish your reception based not only on the strength of your samples but also on how persuasive you are in making a compelling, logical case for hiring your firm (more about presentation skills in Chapter 5).

You'll recall that in the introduction to this section I said that I photograph relevant samples of work I've completed. While only a handful of these projects are showcased on my

"touchy-feely" examples of the work I'd been showing are always well received. Aside from the more expected print samples such as annual reports or capabilities brochures, I try to include at least one of the "problem/solution" (or "before/after") pieces that form the basis of my rationale for engaging my firm.

Shown here are a few of the several portfolio prints that I use for demonstration and pass-around (see Figures 4-1, 4-2, and 4-3). Note how the descriptive wording of each is kept to a bare minimum and how the three elements on each print have been laid out to subliminally reinforce our design capabilities.

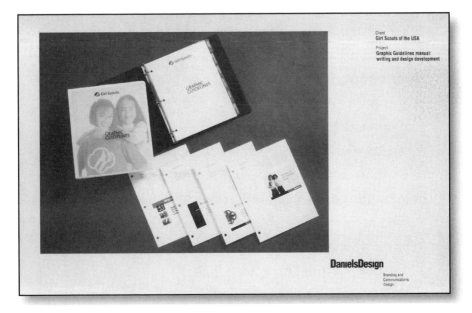

FIGURE 4-1 · Girl Scouts Graphic Guidelines Manual

website, I maintain a complete file of them, arranged cat-egorically (i.e., Manufacturing, Financial Services, Institu-tional, Healthcare, etc.) so that I can tailor a presentation to a given audience quickly and convincingly. The large volume of work that my firm has produced over the years allows me to "mix and match" presentation samples to support my assertion of being able to bring industry-specific experience to the table. I never overwhelm a prospect with a volume of work simply because I can; to me, "sample overkill" is like a guest who has overstayed his welcome—it infringes on the time the prospect has set aside to see you and can quickly turn an otherwise receptive situation south. Again, less is often more.

My samples are shot as transparencies and presented either as mounted chromes (on a flat-panel lightbox that fits inside my portfolio and can operate on either battery or electric power) or as print output that I've easel-mounted on boards for larger audiences. I shy away from slides or digital projections for two reasons. First, they generally require a controlled lighting environment for optimum effect—some-thing that's often impractical if not impossible to ensure in office settings with centrally controlled overhead lighting. Second, project details such as typography—elements so important when selling graphic design services—are usu-ally lost or obscured in projection.

I also make certain to include a few printed samples in all of my presentations. Distributed as pass-arounds, these

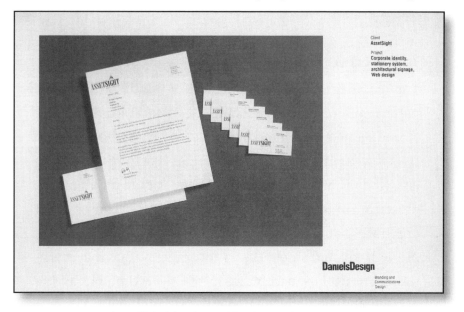

FIGURE 4-2 AssetSight Identity and Stationery System

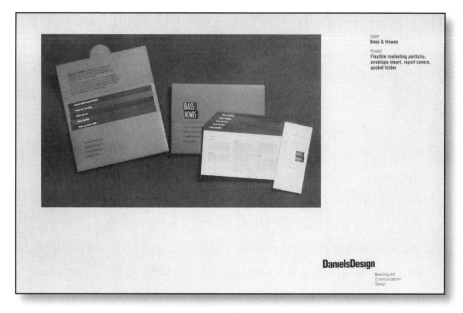

FIGURE 4-3 Bass & Howes Flexible Marketing Portfolio

Your Brochure

The old adage of "out of sight, out of mind" provides the perfect rationale for producing a collateral leave-behind. Not too long ago, a large portion of my firm's billing came from developing imposing capabilities brochures for my clients; today, many of these clients have opted for an online presence almost exclusively. Their arguments against print are those that are commonly heard: print is too expensive; printed collateral gets dated too quickly; having everything online has become as perfectly acceptable as the office phone being answered by voice mail instead of by a receptionist. All the more reason, it seems to me, to maintain a strong, adjunct presence to web-based marketing in print.

To me, print is the most intimate and compelling form of corporate and marketing communications. It establishes a palpable and memorable connection to its audience by engaging multiple senses through the use of design, dimension, materials, and manufacturing techniques. Print is tactile, tangible, and enduring. And, in support of content, it carries an important, subliminal message of credibility, excellence, and stability in ways that electronic media simply cannot. What's more, digital printing has come way down in price while quality has soared, making it practical and cost-effective to update and/or tailor information on an as-needed basis.

This rationale, by the way, makes a pretty persuasive argument for you to use when trying to convince your clients to embrace print as an important adjunct to *their* electronic marketing communications.

5

COMMUNICATING CREDIBILITY

SHAPING AN IMAGE THAT SHAPES PERCEPTION

Let's face it: The way in which you're viewed by colleagues, clients, and prospects will pretty much determine how successful you're likely to be in reaching your professional goals, both as a designer and as a businessperson. Let's take a look at some of the elements that can help you shape an image and build a reputation that instills trust in your abilities and respect for your counsel.

Here's an important but often overlooked and/or undervalued truth: When you represent your firm, *you* are its face—and by extension, its fate. How you're perceived, not

only by your primary contact but by others within the walls of your prospect's or client's company, establishes an indelible impression that will ultimately determine how successful you'll be in landing new and repeat business for your firm. This is especially true in the case of larger clients, where your contacts will understandably need to demonstrate to their supervisors that the trust they've placed in your ability to deliver on the project you were assigned will reflect positively on *their* decision-making skills.

Establishing and maintaining that comfort level takes work—especially if you intend to present your business as something larger than it actually is. Your credibility is largely determined by what I call "the four P's": Portfolio, Personality, Professionalism, and Persistence. Let's look at each in turn.

Portfolio. It goes without saying that your portfolio is your firm's primary calling card. Although we discussed this subject in Chapter 4, these points bear repeating: The level, quality, and creativity of the work you've completed for others will obviously carry the most weight in the decision to engage or pass on the services you're offering. The approach that I've found resonates most favorably with prospects is to present a balanced range of samples that demonstrate a thoughtful problem/solution approach to communications design rather than a purely aesthetic one.

The quandary that most often confronts start-up design firms is their lack of meaningful, compelling samples to show. There are two ways to address this dilemma. First, remember that you've every right to take credit for whatever level of work you've completed while in the employ of others. Second, it's perfectly acceptable to create and display a few "experimental" projects that you feel will aptly demonstrate your approach and abilities in lieu of actual assignment samples. Just remember to be honest about their origin and to replace them with commissioned work as soon as possible. Hint: Although tempting, don't *ever* make the mistake of demonstrating how you'd redesign an existing piece of your prospect's marketing literature; it's presumptuous, it devalues your work, and it tells your prospect that you have way too much free time on your hands.

Personality. How you come across to others will likely determine your chance of scoring either a hit or a miss with prospective clients. A good rule of thumb here is to always put yourself in the prospect's position; doing so will give you a pretty good idea of client expectations and whether you'll need to adjust your personality in order to better meet them. And by "adjust," I don't mean to imply that you should pretend to be anyone other than yourself; I simply mean that if you learn how to quickly "read" your prospect, you'll likely be better able to fit his or her

expectations. Personally, I've found that coming across as relaxed and knowledgeable—certainly about your own business and to a lesser degree your prospect's (without sounding pompous or arrogant about either)—quickly tends to melt away those initial feelings of apprehension and formality that begin most new business encounters.

If I know that I'm going to pitch a new prospect, either "cold" or by way of a referral, I make certain that I've researched background information about that prospect before setting foot in the door. There's another "icebreaker" I use that you may also want to consider: When appropriate, I interject "personal parallels" that may come up in the course of conversation, such as kids, school, commute, weather, and so forth. I find that this kind of small talk often lightens the formality of the initial meeting and adds a dimension of common ground to your qualifications—one that heightens a sense of compatibility and camaraderie.

Professionalism. Your ability to project a consistently high level of professionalism—both in the work you deliver and in the counsel you provide—is essential to establishing a requisite comfort level in the minds of your clients and prospects.

Being acknowledged as professional by your peers and by the people you depend on for your business hinges on your ability to both explicitly and sublimi-

nally communicate an amalgam of attributes—traits that blend together to project a desired image of what others will ultimately view as "professionalism." While these traits certainly include your level of creativity and your design abilities, they also encompass your general knowledge base, your maturity level, your reputation and attitude, and last but by no means least, your appearance. Although "appearance" may seem trite in comparison to these more consequential characteristics, believe me, it's not. How you present yourself physically plays an influential role in determining whether you can be expected to hold to the professional standard you're persuading your audience to buy into.

My advice: Keep yourself fit and dress appropriately. While "neat casual" aptly describes my everyday "uniform," I make certain to alter my appearance when I feel that circumstances warrant it (including wearing a suit and—ugh!—tie when I feel it's appropriate). What I certainly don't do—and I advise you don't either if you hope to be taken seriously—is to affect what some designers see as the need to play up their creativity and individualism in the way they dress. If you feel strongly that that's the image you want to project, fine; but I speak from experience when I tell you that you'll only be hurting yourself.

Persistence. Like it or not—and most designers I know certainly don't—ultimately it's your selling ability that

will determine the success of your firm. The "art" of being persistent without being annoying is an acquired skill that, like anything else, requires an innate sense of when to push ahead and when to pull back. If I feel that I truly have something of value to offer besides just "design services," and/or if I sense a budding rapport with a prospect, I'll make a concerted effort to pursue that party on a regular basis—maybe bimonthly for the first month or so, then monthly if nothing positive occurs in that time frame, and finally semiannually, just to stay in touch (and to keep abreast of any changes that may tend to impact the relationship). You'd be surprised at just how effective persistence can be in keeping your name out there.

I've found that a key to turning prospects into clients is to ensure that these points of contact are more relevant than rote. To me, relevancy means sharing elements of my business activity that I think the prospect may find meaningful, keeping abreast of any specific or industry changes that may impact his business, and using snippets of that dual information to offer constructive suggestions that just may pique his interest or lead to a referral.

GETTING TO KNOW YOUR PROSPECT
Pre-pitch research

Prior to giving any new business presentation, I make an effort to find out, first and foremost, why the prospect is

seeking a new design source. I also try to learn whatever I can about the company and the key people I'll be pitching to. Sources for this research include referrals, the Internet, the company's website, its annual report, and business networking sites. Perusing the target's website provides an ideal opportunity to both learn about your prospect and critique the site—not only from a design standpoint, but also in comparison to the prospect's competition in terms of content, navigation, and perceived effectiveness.

An important word of caution here with regard to effectiveness: Since at this stage in your relationship it's generally assumed that there's no way you can know the logic behind decisions relating to *any* of your prospect's marketing communications, be extremely careful (and/or very general) when offering unsolicited critiques of your prospect's materials. Voicing your opinions at this early juncture could easily (and rightfully) be taken as arrogance. It could just as easily backfire on you by reflecting negatively on one or more of the very audience members you may be pitching to: people who might've had a hand in creating, writing, or directing these marketing tools.

HONING PRESENTATION SKILLS

For most of us, this is the really hard part—and while the adage "a picture is worth a thousand words" may hold true for gallery showings, the reality is that the selling of com-

munications design must be backed up by written and verbal communication skills that support and advance the quality and relevance of your work in a professional, compelling way.

By "quality," I mean that you should strive to rationalize how design can be used to influence perception and in turn, how perception can be used to shape reality. Presented in a carefully reasoned way, this logic can be a powerful persuader for engaging your services. Similarly, when I'm pitching new business, I attempt to make a reasoned argument extolling the economic and marketing sense of using an outside design resource to those prospects who employ in-house art departments. The relevant arguments include being able to see problems from an outsider's perspective by providing more objective thinking and execution; being able to better control project costs; not having to pay for staffing expenses or downtime; providing the ability to meet and/or beat deadlines; and serving as an extension of the prospect's workforce. All of these are valid and influential points that will likely ring true with your prospect.

In my case at least, I'm able to back up the relevance of these points with the fact that several of the clients I work with do have design and production staffs on payroll. If you don't have this background information about the prospect but still want to support the premise of this argument, a simple phone call to your prospect's marketing department will

likely provide you with the information you'll need to learn whether that company engages outside assistance.

Now let's turn to "relevance." By relevance, I mean being able to relate the examples you're showing to issues your prospect may be facing. There should be no surprise here, but the reality is that corporate types traditionally view designers differently than they view almost any other grouping of business suppliers. This perception can be used to your advantage by demonstrating an insightful understanding of your prospect's business model and of the marketing issues the company may be facing—issues that, true to form, many of your colleagues have not thought to exploit. Of course, this tack also has the potential to spell trouble if not approached in a sensible way. At the risk of repeating myself yet again, diligent pre-presentation research is the key that can set you apart and above and provide you with the "leg up" you may need to close the deal.

OVERCOMING JITTERS

For me (and most other designers I know), the act of prospecting and pitching new business is viewed as a necessary albeit distasteful component of the design business mix. While it comes fairly easily to me now, selling and presenting are still two activities that I'd much rather leave to others.

I realized early on in my career that I had a genuine problem with these issues, one that I understood had to be

addressed if I ever hoped to bring in the range and quality of business that I knew I was capable of handling. There was no question in my mind that the level of my work product far exceeded my ability to sell it. I felt underqualified and overwhelmed in selling and presenting to the very businesspeople I had to reach if I wanted to grow my firm. Compounding this predicament (in my mind at least) was my decidedly New York–tinged inflection; I was uncomfortable with my presentation skills and believed that it showed.

Therefore, once I began to generate enough of a cash flow, I hired someone to flesh out and pitch new business for me. Although I thought I had adequately prepared this person to present on my behalf, it quickly (and painfully) became obvious that the arrangement was not going to work—for while it may have been true that his presentation skills were far better than mine, once a prospect began to question decisions relating to a project sample being shown, or ask my representative how he might approach a design problem, he was at a loss to articulate satisfactory answers. This uncertainty resulted in audience skepticism that effectively shattered any credibility I had hoped he would be able to project.

And so, distasteful as it was, I realized that because new business pitching was an interactive exchange, I'd have to suck it up and become more involved and more comfortable with this vital aspect of my business or accept that I'd probably never be able to move beyond my current roster of clients.

With that in mind, I engaged the services of a voice and speech coach who worked with me on preparation, delivery, and diction (losing my "Noo Yawk" inflection and remembering to pronounce the letter *r*, for example) to help me build the confidence I needed to conquer my anxiety and present more effectively. It worked for me and it can work for you too. As I said earlier, I've found that engaging in pre-meeting small talk—be it the weather, office decor, commuting distances, whatever—can help to establish a rapport and comfort level that tends to ease presentation jitters considerably. Needless to say, it's important to come across as knowledgeable, confident, and affable to your audience, whether that audience is one person or a roomful of people.

And while I'm on the subject of a roomful of people, there's another anxiety-producing situation that I've come up against again and again, and maybe you have too—that is, remembering names. It's embarrassing and it's stress producing. Here's what happens to me: Typically, when I've been invited to present to a conference room full of senior staffers, the person who extended that invitation is someone with whom I've had contact previously. The other participants, having been briefed beforehand on the meeting, know me by name, but immediately after they introduce themselves, I tend to lose track of who they are. This was a real problem, one that used to trip me up when I'd be asked to respond to questions from one or more of them.

I needed to find a subtle solution to what was becom-

ing a major thorn in my side. Unexpectedly, the remedy to this vexing problem came from a participant at one of these meetings when, while introducing himself, he handed me his business card. It was a completely natural exchange that to my mind was brilliant in its "why hadn't I thought of that before" simplicity. From that point on, whenever I found myself in a similar setting, I made it a point to swap business cards with each of the meeting participants, noting where they seated themselves and discreetly placing their cards in that position on my open notepad. Problem solved—with no one the wiser.

6

EFFECTIVE BUSINESS WRITING

The cornerstone of firm growth

GOOD DESIGN IS NO EXCUSE FOR BAD WRITING

From everyday correspondence to proposal writing to penning articles for professional journals, good business writing skills are essential to the health and well-being of your business. And although word processing tools may provide assistance with fundamental spelling and grammar issues, it's style and composition—the meat of compelling content—that will still be in your hands. While it's true that "form

letter" software aids abound, it's up to you to ensure that B2B written communications mirror the uniqueness, professionalism, and individuality of your firm's work product. In my experience, the only thing that will sink your fledgling business faster than substandard work is weak and/or amateurish business writing and presentation skills.

My advice? Grade your business writing objectively against a professional standard. Learn and use proper English and grammar in *all* of your correspondence—from "tweets" to proposals. And as I recommended when discussing verbal presentation skills, I would strongly suggest that you seek assistance if you need to polish up your business writing abilities. If your community is anything like mine, chances are there are plenty of noncredit business writing courses available for you to take at your local community college.

Most of my initial contacts with prospective clients are conducted either in person or on the phone. Unless I'm specifically requested to do so, I make it a point never to use email—even if it's on an electronic version of my firm's letterhead—for sending or attaching *any* sales material. Why? Think about it: Given the amount of electronic correspondence your prospect likely receives each day, your message stands a far greater chance of standing out, being read, and being acted upon if it's packaged in a way that sets you apart from the herd and reinforces the level of professionalism (and yes, even old-fashioned protocol) that your firm hopes to project.

Here are a few other tips to help ensure that your sales material will be noticed:

- Never stuff sales correspondence into a #10 envelope. You want your package to arrive in the same condition you sent it in. Together with the fundamental stationery suite of items that you print—your business card, letterhead, second sheet, and mailing label—I would strongly suggest that you prepare a pocket folder for use in presenting your cover letter, card, proposal, and marketing materials.
- Because it will be representing your firm, never use an off-the-shelf folder like the kind you can pick up at any office supply store. Instead go for the extra bucks and design one that will be representative of your business. Folder art can be as simple as printing your logo on the front panel and having your USP (see Chapter 4) on the inside of the flap. However you decide to go, my advice would be to keep folder text as generic as possible to ensure a long and useful shelf life.
- Instead of the standard 9″ x 12″ vertical variety, you might want to turn your folder on its side; the 12″ x 9″ horizontal format gives the folder a more unusual portfolio appearance. I use my pocket portfolio both as a mailer and as a leave-behind at meetings. My folder includes an introductory signed letter, a page consisting of my bio and the bios of those "team members" whom I tap on a

regular basis to work with me on project assignments, our capabilities brochure, and finally, a few relevant testimonials from clients.

Over the years, I've developed some frequently used letter formats that allow me to quickly customize correspondence to suit specific situations. These formats include a new contact letter and a follow-up letter, both of which are reproduced in the next sections. Keep in mind that what's shown in those examples is boilerplate content; I strongly suggest that you use these only as a reference for crafting your own custom templates.

THE NEW CONTACT INTRODUCTION LETTER

Assuming that you want your "cold" letter to be acted upon, it's important that your correspondence contain three key elements: (1) a frame of reference that the recipient will be able to relate to; (2) an overview of your unique qualifications; and (3) a call to action.

I use a simple block-style letter format that aligns the body of the letter both vertically and flush left with a printed element (i.e., my logo) on my letterhead. The resulting correspondence creates a unique, proprietary look that subliminally reinforces my design capabilities. I suggest that you establish a unique look for your communications as well.

The frame of reference for this particular example happens to be an introductory letter directed to a new hire who had

taken the place of my previous contact at my client's company (needless to say, that previous contact was invited to share his story and future plans with me at lunch—never burn bridges). The opening paragraph of *your* letter should also seek to establish some level of connection in order to segue meaningfully into a rationale for granting you an appointment.

Date
Name
Title
Company
Address
City State Zip

Dear (name),

I was recently made aware of your appointment as (job title) and wanted to take this opportunity to introduce myself to you and give you some background about my firm and our relationship with (company). We had initially been introduced to (predecessor name) by (referral name). You may already be familiar with some of the projects we've completed for (communicative company name*): most recently, the design and production of last year's annual report, white paper, and executive stationery.

DanielsDesign provides strategic branding and inte-

grated communications solutions to organizations of all sizes seeking to position and leverage their unique cultures and attributes into a strong and influential brand voice in order to raise visibility, shape perception, and build awareness and credibility with target audiences.

I've enclosed a firm brochure for you to review along with a few of the many endorsements we've received over the years from our clients. I think these enclosures will give you a pretty good idea of the strength of the relationships we've developed and of the consistent quality of work that you can expect from us. You can also see examples of how we approach and solve a broad range of communications problems for our clients by visiting us online. *(Note: Your URL should appear on your letterhead and all other marketing materials.)*

I'd welcome the opportunity to extend our professional relationship with (communicative company name*). I'll give you a call next week to see when you may be available to meet with me.

Sincerely,

(Printed name below full signature)

* *In case you're wondering, commonly referenced acronyms or abbreviations such as "IBM" in place of "International Business Machines" is the difference between "communicative" and "corporate" names, respectively.*

THE FOLLOW-UP LETTER

This next example is a follow-up to a "show-and-tell" meeting with the practice development manager at a mid-size law firm. I've found that law and accounting firms make desirable prospects because many of them, having arrived relatively late at the marketing gate, have a strong desire (make that *need*) to capture a slice of market share within their demographic. As with any prospecting effort, in order to compellingly link your capabilities to your prospect's needs, it's vital to do at least some relevant pre-pitch homework. Depending on the degree of formality that you feel may be appropriate for the occasion, you can opt to exclude the prospect's formal address information.

Dear (Name),

Thank you for inviting me in this morning. I enjoyed meeting with you (and others if warranted—by first name[s]) and learning more about some of the many marketing-related issues you face at (firm name or abbreviation). I think that we can be of help to you and your staff in strengthening the firm's overall marketplace presence through the development of a narrowly focused branding program.

The goal of such an undertaking would be to establish

a proprietary graphics system aimed at reinforcing a consistent, cohesive leadership presence for the firm in the preparation of both print and electronic media. I would be happy to prepare an activities blueprint outlining the steps necessary to establish a set of cost-effective guidelines that can expand or contract as needs and budgets dictate.

Whether for full program development or partial support, you'll find that DanielsDesign delivers an unmatched balance of creativity, perspective, and disciplined management to every project entrusted to us. We understand the power of perception and brand integration, and strive to help our clients build credibility, continuity, and brand equity into all of their communications—without the overhead or management layers typically found in larger firms.

I'll give you a call next week to see whether you'd like us to proceed with the blueprint without further obligation on your part.

Best,

(Printed name below full or abbreviated signature)

7

CRAFTING A WINNING PROPOSAL

COMPOSING THE *REAL* ART OF THE DEAL

Here's a little fact that may surprise some of you: While your client or prospect may think the world of you both as a person and as a designer, the project proposal you submit for consideration is the one vehicle that can usually make or break a budding (or even ongoing) relationship.

With so many questions to be considered, I find that crafting a compelling, spot-on proposal is often the toughest part of securing new business. Questions abound: Have I demonstrated my grasp of the assignment correctly? How

The forms in this chapter are available for download at www.amacombooks .org/go/GraphDesign.

detailed should I be in structuring my estimate? How much is the prospect prepared to spend? How complex will this assignment become? How do I cover myself for contingencies? How many other firms are being solicited for this project? Is there potential for building an ongoing relationship with this prospect or will this be a one-time assignment? How can I find out the company's payment history?

The answers to many of these questions can be culled from the creative brief—a document that provides me with most of the core information I'll need in order to structure an intelligent, persuasive proposal.

The dialogue between you and your client or prospect during that fact-finding meeting should be engaging and animated. Take notes, but remember that sometimes the "inside story," which the briefing questions *can't* necessarily convey, is often found in your interpretation of the prospect's body language, in references, or simply in his or her general demeanor—subtleties that, correctly interpreted, may provide you with just the edge you need in order to craft a proposal that will resonate with your prospect on a more meaningful and insightful level than any of the others that have been received. During this initial meeting I just jot down what I consider to be some key points to be expanded upon once I'm back at the office. As soon as the meeting is over, though, I'll often record my thoughts on a small digital voice recorder that I keep with me. I find that with all of the other things that I have going on, the recording helps me to keep fresh ideas fresh.

ESTABLISHING CREATIVE METHODOLOGY

The heart of any design proposal is your approach to the creative process itself—the unexpressed methodology you employ that enables you to make an accurate projection of (a) just how you'll undertake the project at hand, (b) how much time you're intending to devote to it, and (c) how much profit you can expect to wring out of it.

Because designers are often at a loss to explain "creativity" and how it applies to the design process, I've done some research to try to put this often elusive approach into a context that can help to define the process.

Search "The Creative Process" online and hundreds of explanations, both verbal and visual, compete for attention. Being a visually oriented guy, I instinctively gravitate to the illustrative models: pie charts, flowcharts, graphs, diagrams, and histograms from the utterly simple to the ridiculously complex, all attempting to define and clarify the process of coming up with ideas that are unique, meaningful, and enlightening.

To me, the big drawback with each of these models is that in their attempt to guide creativity as an ordered, step-by-step process, they (a) largely remove individualism from the creative equation and (b) don't account for deadlines—the one constant in the communications design process.

For the graphic design professional, the creative process is far less an academic exercise than it is a economic one, as success is dependent on your ability to constantly come up

with clever, workable solutions to market-driven problems in ways that will cause an anticipated action on the part of the target audience.

Unless the designer is involved in the more "decorative" (read: design for the sake of design) aspects of the profession, commercial graphic design is far more than just an aesthetic exercise. In order to be effective in meeting project objectives, deadlines, and budget constraints regardless of individual approach, marketing-based design almost always follows a carefully structured process that begins with discovery and ends with deployment. Rather than limit creativity, in many ways the restrictions imposed by "real-world" factors tend to more tightly focus the creative process.

As in other design disciplines—architecture, interior design, industrial design, fashion design, etc.—the most creative solutions in graphic design are almost always driven by these three core ingredients:

1. The raw talent needed to envision and express ideas conceptually
2. A mastery of the tools and processes needed to implement those ideas
3. An in-depth understanding of the objectives in undertaking the project at hand

For me, the way in which I approach the design process is largely driven by four factors:

1. The budget allotted for the work
2. The scheduling demands of the project
3. The complexity of the undertaking
4. The integration of the assignment

Let's look at each of these components in turn:

Budget. Having a solid grasp on a project's budget from the very start is essential in establishing design parameters that will in turn affect all of the physical aspects of the job. These include size, shape, color, graphic elements (including the possibility of using stock or commissioned illustration and/or photography), and production. Understanding the limits you have to work within is vital in gauging the design approach you'll be taking.

Scheduling. More often than not, deadlines are a determining factor in the design process. I always get a kick out of those long-winded descriptions of the creative process as a drawn-out, step-by-step process that first seeks to examine every aspect of the project at hand, then establishes models to consider, next collects feedback, then modifies a direction, after that establishes a consensus, and finally implements a concept to present. If other designers' clients are anything like mine, by the time that concept is presented for consideration having followed each of these steps, the client will likely have taken the project assign-

ment to another firm. The reality is that in the fast-paced world of commercial graphic design, creativity and scheduling are not mutually exclusive ingredients in developing design solutions. Because I tend to work better under pressure even when I'm not being driven by a tight deadline, I generally impose one for myself.

Complexity. Complexity refers to the number of elements that I'll have to incorporate within a project assignment—for example, where an ad may be relatively simple to develop with as few as five elements (a visual, a headline, body copy, a logo, and a layout to hold them all together), an annual report may contain a multitude of different components that all have to work seamlessly together.

Integration. Integration deals with design parameters that must be considered when the project at hand has to become visually assimilated into an overall theme. A good example of this occurs when the designer must comply with a set of graphic standards that have been developed in order to project a cohesive, branded look to all of a company's corporate and/or marketing communications.

Hopefully, my approach to creativity will provide you the direction you'll need in order to better quantify your own mechanism for evolving and managing the design process, beginning with the creative brief.

Figure 7-1 reproduces the creative brief I use.

DanielsDesign

Creative Brief Date _____

Contact information

Primary contact name, title, contact info.

Overview

Project information, purpose, objectives.

Deliverables needed

Copy, design, photography, printed materials.

Target audiences

Identify primary/secondary audiences; note points to be stressed and avoided.

Tone and image

Funny/casual? Serious/formal? Combo? Cite primary message tone needed to resonate
with target audience in order to maximize desired response.

continue page 2

FIGURE 7-1 Creative Brief

DanielsDesign

Creative Brief *continued*

Message priorities: Features, benefits and value

Cite (in order) the features and/or facts about the program and its value to target audiences. What's the one sentence that summarizes its unique value. Other key points?

Budget and schedule

Has a budget been approved? When must the message get to the target audience for greatest impact? Due date for finished work?

Additional information

New or replacement communication? Competition material relevant? Available for review? Note any other information needed in order to craft an acceptable proposal.

FIGURE 7-1 Creative Brief (*continued*)

Now that you are armed with a good sense of project scope, the next step to tackle is working out fees and outside costs in order to come up with an estimate that strikes a balance between profit and acceptance of the proposal by the client or prospect. My approach to this dilemma is to break out all of the anticipated project components in an organized way so that I can come up with a number that I feel will comfortably cover all of my time and expenses. Once that's determined, I can begin to craft my proposal around these numbers, outlining my take on scope and deliverables in a way that will justify the numbers I'm proposing (you'll note that my terms and conditions provide for a contingency to cover unanticipated shifts and allow for some "breathing room"— see Figure 7-2).

Because I want my proposals to be inviting instead of intimidating, I try to keep any legalese to a minimum, citing in plain but professional language those things that I feel may be necessary to communicate my grasp of the problem at hand, offer a focused and manageable approach to its solution, and, finally, protect my interests. Proposal terms and conditions often vary with the complexity of the assignment and with my relationship to the client.

Generally, I prefer to have a signed hard copy—either by return mail, by fax, or in PDF format for my records; however, given the prevalence of email, the line that usually states, *"If this proposal is acceptable to you, please sign and return one copy for our records"* can easily be modified to read *"If this proposal*

DanielsDesign

Proposal Worksheet Proposal Number_____

Inside fees	Time	x	Rate	Amount
Proposal prep				
Design consultation and development				
Art direction				
Briefing / presentation meetings				
Specs prep				
Distribution and evaluation				
Travel				
Administration				
Other				
	Sub Total Fees			$

Outside costs

Service	Vendor	Quote	Mark-up (%)	Amount
Expenses (Disks, courier, materials, travel, etc.)				
Contingency				
		Sub Total Costs		$
		Estimate Total		$

FIGURE 7-2 Proposal Worksheet

is acceptable to you, please print out, sign, and return via fax for our records." Or, consider this form of endorsement, in which case the signature lines would not be needed: *"If this proposal is acceptable to you, please advise by return email. Your response will serve as our authorization to proceed as stated."* Whichever method works best for you, make certain that you have a valid authorization to proceed with the assignment before beginning work on it.

Here's the basic proposal template that I've developed. This one happens to be for the creation of a brand identifier; you can easily substitute the project assignment that you've been asked to bid on in its place:

Proposal to Develop a Brand Identity for (Client/Prospect Name)

(Your firm name) is pleased to submit our proposal to create a unique and appropriate brand identity for (client/prospect name). Our goal in undertaking this assignment will be to identify and leverage those distinct attributes that will serve to define both the company's products and its culture, and to express them visually through the creation of a unique and appropriate brand strategy, beginning with the creation of a graphic identifier. The endorsed logo will serve as a focal point for building a comprehensive graphics program, one that will enable

(company name's) products (and/or services) to speak with a clear, compelling, and consistent brand voice.

Our approach to this assignment employs a series of steps intended to focus and expedite the creative process:

STEP 1: Design Exploration

After an initial consultation with management, we will explore and present three brandmark concepts for consideration. Each will be aimed at visually encapsulating those attributes that accurately reflect the firm's core competencies and vision from a branding perspective. Concepts will include a rationale for the development of each concept, as well as a practical demonstration of application both as a stand alone and applied to essential stationery items.

Schedule estimate: 2–3 weeks

STEP 2: Concept Selection, Refinements, and Application Controls

Based on management feedback, we will refine the selected concept as may be required, and re-present it for final management endorsement. During this step, we will also provide basic usage standards relating to primary and ancillary typography, color, layout, and other relevant factors.

Schedule estimate: 1–2 weeks

STEP 3: Prepress Preparation

Finally, we will prepare digitized master artwork of the company's new brandmark for submission to the U.S. Patent and Trademark Office for a search and determination (via your attorney). This will complete this phase of our assignment as stated.

Schedule estimate: 1 week

FEES AND EXPENSES

We agree to provide the deliverables outlined in steps 1 through 3 for a fee of $ 0,000 +/– 15%. This fee includes all development, administrative, and project management services plus two rounds of reasonable and customary edits applied to each work phase. Additional edit rounds, if required, will be charged at current hourly rates of $000 for creative and $00 for production services. This proposal is based on our current understanding of this assignment. Changes in project scope may require a corresponding adjustment to the proposal. Such changes will be submitted for your approval prior to implementation. Out-of-pocket expenses, including but not limited to presentation materials, prints, digital media, and courier services, are additional to this proposal. Generally, these out-of-pocket costs do not exceed 10% of the development fee. Expenses will be documented and itemized on

corresponding invoicing. Invoices are issued either upon completion of this assignment or progressively at 30-day intervals or at the end of each work phase, whichever comes first. Terms are net 30 days with a service fee of 1.5% added to the unpaid balance.

THE NEXT PHASE

Once registration is approved, we will submit a proposal covering the design and implementation of the brandmark applied to marketing brochures, merchandise branding, architectural signage, and/or other items to be mutually determined at that time.

Thank you for considering (firm name). We look forward to working with you on this important assignment. If this proposal is acceptable to you, please endorse and return one copy for our records by mail or courier. If necessary, I'll gladly consider any changes or refinements that you feel may be warranted in order to make this proposal acceptable to you.

Sincerely,

(Your signature)

Accepted for (legal client/prospect name) by:

X _____ ___/ ___/ ___

Print name and title:

In order to demonstrate your understanding of and general approach to the assignment, it's critical to cover those points in the opening paragraph of the proposal. The prospect proposals I prepare are always accompanied by a cover letter that references the project and cites my firm's qualifications relating to the proposed work. Note that the last paragraph of the proposal includes a sentence offering to negotiate fees in order to secure the assignment. Remember that the perception of value that you're proposing is subject to interpretation based not only on budget, but also on the sophistication level of the prospect. While you certainly don't want to "give away" your services through discounting, you must also assume that other design firms are being solicited for this assignment as well.

When considering whether to negotiate fee adjustments on a proposal, I try to predict the probability of extending the

assignment into other avenues and the likelihood of building a long-term relationship versus a "hi" and "bye" project. These are judgment calls that require you to carefully balance the pros and cons of any fee modification(s) that you agree to.

You'll note that in step 1 of this sample proposal, deliverables include a rationale for the development of each identity-based concept that I present. The reason for doing this is significant: With the understanding that design decisions are often based only on subjectivity, and that the presentation will be passed around to others to comment on after I've made the in-person presentation, providing the logic behind each concept ensures that my thought process will be accurately communicated to those responsible for decision making. That's why almost all of my presentations include both easel-mounted concepts and bound leave-behind booklets that address each step in the design exploration process sequentially, ending with a "next step" call to action.

Although my agreement's terms and conditions outline my proposed fee, included and additional edit rounds, billing of expenses, proposal specifics and caveats, payment terms, and proposed scheduling in simple, straightforward language, there are certain circumstances—such as may be the case with large and/or multiphased assignments—in which you may find that an expanded version of those terms and conditions is more appropriate in providing greater safeguards for you.

Take a look:

PROFESSIONAL FEES AND EXPENSES

(Your firm name) fees are estimated on a descending rate scale commensurate with anticipated time requirements and functions necessary to complete each task or work phase noted herein.

As compensation for our services you agree to pay us within the fee range stated in this proposal. This estimate is based on our current understanding of the project as described. Due to the nature of the creative process, deviations from the specific steps, scheduling, and/or estimated fees outlined in this proposal may occur as the assignment evolves. Changes in scope, major revisions or alterations, client-generated overtime, or other unforeseen contingencies may serve to increase or decrease this estimate. We agree to advise you in advance and obtain your authorization to proceed if such changes apply.

PAYMENT

Invoices are issued either upon completion of this assignment, at the completion of each component or phase, or progressively at the end of each 30-day period. An advance equaling one-third of the estimated fee is payable upon acceptance of this proposal. Terms are net 30 days with a service fee of 1.5% added to the unpaid balance. Sales tax will be added as required by law.

CANCELLATION

In the event you cancel this assignment after acceptance of the proposal, unless a specific "kill fee" is noted, you agree to notify us in writing of your intention. You shall be liable for all services performed and expenses incurred up to the date of receipt of the cancellation notice.

CREATIVE RIGHTS

Unless otherwise noted, this agreement covers only the final concept that is delivered. That concept becomes your exclusive property upon receipt of payment in full. All other concepts and designs developed in the course of this project remain our property. Reproduction rights to photographs, illustrations, and/or technical drawings remain the property of their respective copyright owner(s). We will promptly assign you the materials needed to apply for trademark registration and/or copyright applicable to this assignment. For this purpose you will use your own attorneys and agree to assume any expenses arising from these procedures.

INDEMNIFICATION

You agree to assume final responsibility for the proofing of all copy, content, and manufacture as may apply, and to indemnify us against any damages, costs, or losses that may be suffered as a result of any claim arising out of the

services performed or materials prepared by us in connection with this assignment. Purchases of printing, fabrication, and/or other major production expenses may be invoiced directly to you from the vendor(s) subcontracted by us.

In such instance(s), payment will be subject to each vendor's policies. We make no warranties with regard to any third-party suppliers.

SECURITY

We agree to make every effort to ensure the strictest confidence as it relates to any proprietary information that you may provide to us in the course of this assignment. After it has been implemented publicly, however, you agree to provide us with a reasonable number of samples and grant us permission to include said assignment in our promotional endeavors if we so choose.

If I use this long version, I include a separate page listing current studio hourly rates plus hourly or day rates in effect for copywriters, strategists, illustrators, photographers, and/or any other applicable service providers that may be needed in order to complete the assignment as proposed. I also stipulate a 30-day time frame for guaranteeing the rates I've posted. Aside from protecting you from possible rate changes by third-party vendors, including an actionable time frame also serves as a prompt for the recipient to (hopefully) rev up the approval process.

8

TIME MANAGEMENT

The key to design firm profitability

JUGGLING THE TIME CLOCK

A disciplined yet flexible approach to time management is essential to running a successful design firm, regardless of its size. If "disciplined yet flexible" sounds like an oxymoron to you, believe me, it's not. "Disciplined" refers to the fact that principals of small design firms must don several different hats on a regular basis, including design, project management, planning, prospecting, marketing, bookkeeping, and so forth. "Flexible" recognizes the ebb and flow of everyday events that inevitably results in deviations from

The forms in this chapter are available for download at www.amacombooks .org/go/GraphDesign.

a rigid schedule. The trick in juggling these variables is to manage both your billable hours and downtime efficiently and effectively.

ESTABLISHING BASELINE TIME RATES

I use a baseline of $60/hour as my internal break-even rate. This number was formulated by compiling the overhead costs necessary to keep my business solvent on a month-to-month basis, adding in my annual salary, and then dividing that amount by the number of billable hours in any given month. While this method may seem overly simplistic from an accountant's perspective, for me, it establishes a baseline for judging comparative profit or loss on each job. While your overhead costs may differ, you should consider these recurring items when establishing your baseline time rate:

- Office rent or the prorated amount of rent or mortgage allocated to operating your home office (note that because the amount claimed for your home office may be subject to interpretation by tax authorities, it's best to consult your tax professional with regard to allowances)
- Office/art supplies
- Utilities (including recurring phone and Internet service fees)

- Insurance (homeowners and/or renters; medical)
- Hardware and software (initial costs and updates)
- Advertising and marketing costs
- Professional fees (memberships/conferences)
- Educational advancement
- Legal and accounting
- Miscellaneous fees (e.g., domain name registration)

ESTABLISHING BILLABLE TIME RATES

Unlike baseline rates, time rates used for estimating and billing purposes are formulated to provide me with a reasonable level of profit. Billing rates are based on generally accepted hourly fees for the range of services I provide. By "generally accepted," I mean that I try to position my fee structure in line with other firms that I consider to be on a professional level with mine. As you might expect, factors such as geography and regional economics also play a pivotal role in adjusting time rates; realistically, you can't expect small to mid-size clients in suburban or rural locations to pay "big city" fees in a down economy. In determining time rates, it's also important to remember that perceived value—that often subliminal culmination of factors that a client or prospect mentally attaches to your ability to satisfy his requirements better than the next guy—will almost always be a deciding factor in choosing or passing on your proposal.

TRACKING BILLABLE TIME

With time charges being the principal source of income for a design firm, it's a given that a workable system has to be employed to track billable hours. I use both daily and monthly time sheets to monitor the time and functions spent on each project. And yes, believe me, I'm aware of the many time management software programs out there; for my purposes however, entering start and finish times simply doesn't justify the purchase of tracking software. You should track your time in whatever way works for you.

At my firm, daily time sheets are distributed to all employees, whether staffers, on-premises freelancers—or, for that matter, just me. They cover a Monday through Friday workweek and include columns for the project identifier, start and stop times, and job function (see Figure 8-1). These time sheets document billable hours in half-hour increments calculated on either side of the quarter-hour mark. This arrangement seems fair to both parties without having to calculate fractional amounts (math was never a strong point for me anyway).

At the end of each week, the hours spent on a variety of assignments as logged on the daily time sheets are totaled and transferred to separate, project-specific monthly time summary sheets (Figure 8-2). Depending on how your proposal is structured, these monthly records form the basis for either final or progressive billing. The "1" and "'2" regular

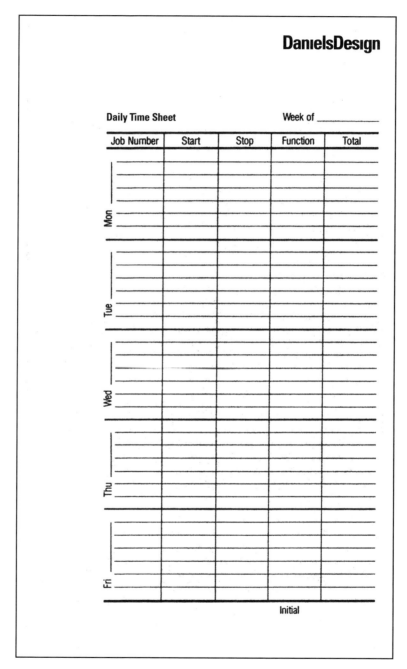

FIGURE 8-1 Daily Time Sheet

DanielsDesign

Time Summary

Project ID [] Year []

Week of _____

	Regular		Revise/OT	
	1	2	1	2
Mon				
Tue				
Wed				
Thu				
Fri				
Total				

Week of _____

	Regular		Revise/OT	
	1	2	1	2
Mon				
Tue				
Wed				
Thu				
Fri				
Total				

Week of _____

	Regular		Revise/OT	
	1	2	1	2
Mon				
Tue				
Wed				
Thu				
Fri				
Total				

Week of _____

	Regular		Revise/OT	
	1	2	1	2
Mon				
Tue				
Wed				
Thu				
Fri				
Total				

Week of _____

	Regular		Revise/OT	
	1	2	1	2
Mon				
Tue				
Wed				
Thu				
Fri				
Total				

Week of _____

	Regular		Revise/OT	
	1	2	1	2
Mon				
Tue				
Wed				
Thu				
Fri				
Total				

Week of _____

	Regular		Revise/OT	
	1	2	1	2
Mon				
Tue				
Wed				
Thu				
Fri				
Total				

Week of _____

	Regular		Revise/OT	
	1	2	1	2
Mon				
Tue				
Wed				
Thu				
Fri				
Total				

FIGURE 8-2 Time Summary Sheet

and overtime notations are used to separate out creative and production time rates.

At the conclusion of each project, I prepare a project cost summary that shows me at a glance the services used in connection with that job; the vendors used for each of those services; the net and gross cost of each service; and a break-out of those services by round. As you can see at the bottom of the summary sheet (Figure 8-3), the first two rounds of edits and/or modifications are included in the original estimate; additional rounds are broken out beneath. The number appearing in either the plus or minus area (to the right of the total) tells me whether I've made or lost money on the project.

I find that project cost summaries also serve as an invaluable reference tool for accurately projecting time and expense requirements on new proposals with similar parameters.

THE NEW PROJECT START-UP PACKAGE

I've developed a project management model that tracks virtually every aspect of an assignment, from inception through completion. All project assignments begin with the start-up package. Each assignment, whether from a current client or a new prospect, begins its life with an entry onto the proposal/work authorization entry log (Figure 8-4), where it is assigned a number that will allow it to be tracked and recalled as needed.

DanielsDesign

Project Cost Summary　　　　　　　　　　　　　Project ID _____

Complete and attach to file invoice

Item	Vendor	Cost	Billed	Remarks	Round
R1&R2 Time #1	#2			Notes	
Expenses					
Sub total					
R3 Time #1	#2				
Expenses					
Sub total					
R4 Time #1	#2				
Expenses					
Sub total					
Total $				+	
				-	

FIGURE 8-3　Project Cost Summary Sheet

DanielsDesign

**Proposal/Work Authorization
Entry Log** Year _____

Proposal number	Log-in date	Project description	Go / No	Project ID

FIGURE 8-4 Proposal/Work Authorization Entry Log

Only the date, client or prospect name, and an abbreviated project description are entered initially. If the proposal is accepted, it is given a "go" notation and assigned a project identifier (you'll recall from Chapter 3 that project identification codes are composed of a two- or three-letter client abbreviation followed by the start number "101" for new clients). If the proposal is not accepted, a notation is made in the "no" box and the proposal is filed away for future reference in the consecutively numbered "proposals" folder that I keep on my computer desktop.

An entry into this master log is made for each and every new assignment, whether or not a formal proposal is prepared.

TRACKING BILLING INFORMATION

The project cover sheet (Figure 8-5) lists all of the relevant data that will be needed for billing purposes. This includes the client/project numbers, the proposal number, and, if applicable, client purchase order numbers. It also contains the log-in date, a project description (and work phase, if applicable), and any other relevant billing information. The cover sheet will hold all billing-related information for the duration of the project, including accumulated time summary sheets, progressive project expense sheets, third-party estimates and bills, and any applicable interim invoicing. Until the assignment is completed, the cover sheet and its

DanielsDesign

Project Cover Sheet

Project ID

Proposal number

Log-In date

Client

Contact

Billing address

Component / Phase

Project description

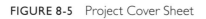

FIGURE 8-5 Project Cover Sheet

attachments are kept in a "work in progress" bin containing all active jobs.

PROJECT CONTENT FOLDERS

Project content folders (or "job tickets" as they're sometimes referred to) are used to store relevant information such as sketches, correspondence, imagery, and anything else connected to a given project. Although most all project information is stored (and backed up) on the computer, I maintain hard copies of every edit round in the project folder for reference just in case—for instance, just in case I have to refer to some aspect of the job and I don't have access to a computer, or just in case I have to explain and/or justify claims or assertions.

Project folders are tabbed with the job number and an abbreviated description of that assignment. The folder provides quick and easy access to all progressive project activity for the duration of the assignment. It is also invaluable at billing time for determining (and, when necessary, defending) additional edit rounds. Not being able to validate chargeable revisions can obviously spell real trouble for you if certain charges are brought into question. Bottom-line recommendation: Document everything.

The traffic sheet attached to the front of each project folder provides an instant snapshot of all past and current project activity and the dates of each handling (see Figure 8-6). Project folders are kept centrally available (I use one of

DanielsDesign

Project Trafficking Year_____ Sheet Number_____

Project No.

Client

Project Title

Log-in Date Action

FIGURE 8-6 Project Trafficking Sheet

DanielsDesign
Progressive Project Expenses

Project ID _____

Week of _____

Phase/Round _____

8 x 10" low rez scans @ $15 _____

8.5 x 11" laser prints @ .50 _____

8.5 x 11" color prints @ $7.50 _____

11 x 17" laser prints @ $1 _____

11 x 17" color prints @ $15 _____

Load/burn CD @ $20 _____

Local messenger @ $11.15 _____

Pkg. service (FedEx, UPS) _____

Retouching ... _____

Other _____ _____

Other _____ _____

Other _____ _____

Other _____ _____

FIGURE 8-7 Progressive Project Expense Sheet

those accordion file folder racks that you can pick up at any office supply store) until billing time, when they're culled for both "toss" and "hold" information and then filed away together with a burned disk containing final repro art.

While files are kept separately for the design and financial phases of a project, the various tracking numbers given to each assignment make cross-referencing an easy and efficient process both during and after the active work phase, thereby saving time and trouble whenever it may be necessary to look up old jobs, identify vendors, match estimates, or check profitability.

TRACKING PROGRESSIVE EXPENSES

Progressive project expenses sheets (see Figure 8-7 on the previous page) are used to track all out-of-pocket expenses associated with a particular project development round. Completed weekly and tallied at billing time, they provide an accurate record of reimbursable expenses by date and phase.

HANDLING DOWNTIME

Downtime is, of course, a fact of life for service businesses. And while it may be great to imagine the revenue stream you'd generate if all of your time were billable, in reality you'd have no time left for any of the other functions necessary for the operation of your business. The key to managing downtime successfully is to use it constructively to address each of the other functions required to ensure the smooth operation of your firm—and your life.

Taking time off without having someone to cover for you requires some sensible advance planning and notification. Aside from making sure that my active client base is aware of my plans, I of course leave an "away" notice on my voice mail and on all of my email accounts. You may see things differently, but I absolutely refuse to stay connected electronically while I'm on vacation. Face it: No matter how important you feel your services are to your clients, the hard fact is that the world will go on spinning whether you're in

the picture or not. Accepting this simple, undeniable fact—realizing that that statement actually applied as much to me as it did to the rest of humanity—was indeed a revelation.

Like so many other entrepreneurs, I guess I was pretty much a workaholic—but a workaholic with a decided difference: I never really viewed what I did as "work." I loved the process of designing, coming up with fresh, clever, workable solutions to problems, often in ways that remained a complete mystery to those outside this business of ours. I also thrived on the satisfaction I got from running my own show—having the independence that so many other folks can only dream about.

To me, the reward didn't come from sipping piña coladas on a beach somewhere; it came from getting new and repeat business, from having something tangible to show for the years of struggling that brought me to that point. In my mind, at least, my work ethic made me irreplaceable—to my clients, to my business, and to myself.

I guess I finally saw the light when my wife reminded me in no uncertain terms that not everyone feels the same as I do and that if I wanted to continue to experience that same level of happiness and satisfaction at home that I had at the office, I'd better learn to spend some quality time away from it. It was an argument that I really couldn't challenge. I came to realize the importance of remembering that no matter how much you may love it, you didn't go into business to become a slave to it. Downtime offers you that rare window

of opportunity to get away from it all and recharge now and then. Again, just make certain that all of your bases are covered so that you won't be faced with a backlog of work, irate clients, late bills, or worst of all, a disappearing client base when you return. And while we're on the subject of covering bases, remember too that Uncle Sam and his regional counterparts wait for no man (or woman) when it comes to the timely filing of tax reports.

Here's the thing—as an entrepreneur, the reality is that your mind doesn't automatically shut down or even change gears all that much whether you're at work or play. Because your success depends on your ability to constantly generate income, chances are you're always thinking about ways to make your time more productive and profitable. If you're anything like me, you've probably thought at some point, "wouldn't it be great if I could somehow generate some of my *own* clients instead of constantly prospecting for new work?" Well, guess what—chances are you can turn that thought into reality. Another valuable use for downtime may be in creating ancillary opportunities for your firm. Chapter 9 will give you some valuable tips on selling and marketing your firm's design services—plus give you suggestions on ways to generate income through ancillary ventures.

9

EFFECTIVE MARKETING

Your passport
to success

SALES
An unavoidable reality

There's really no surprise here; it goes without saying that sales are the lifeblood of a design firm—and every other business venture for that matter, large or small. The difference is that in this industry, especially when the burden of rainmaking falls on the shoulders of the firm principal, the selling effort is often treated like a plague to be shunned until it's impossible to avoid. Like you (and just about every

other designer I know), I too would rather design than sell. The reality, of course, is that if you want to have a business to run, the responsibility for providing work for it falls squarely in your lap.

While the "repeat business" mantra may be a convenient way to rationalize away the need to sell yourself and your firm on a regular basis, it's really a pitfall: Today's volatile business environment can leave even the most solid relationships subject to the winds of change without much advance notice. It's far more sensible to recognize this reality by adapting a consistent, no-nonsense approach to selling your firm's services.

Over time, I've tried to refine and adapt my selling skills to align with the type of design firm I wanted to run: a small, well-respected consultancy known for its creative output, its professionalism in all areas of business dealings, its grasp of client needs, and its ability to manage both small and large projects effectively and efficiently.

In the following sections we'll discuss some of the things I've learned that you may want to adapt to your own situation.

ABSORB LIKE A SPONGE

If you're at all like I was, the business of actually *running* a business will quickly overwhelm and intimidate you as a designer. Like me, you don't have a degree in business administration, and it's a safe bet that you never wanted one. Yet,

when all is said and done, the reality is that if you depend on businesspeople for your livelihood, you had better learn how to "walk the walk and talk the talk" if you want to be taken seriously. My "seat of the pants" approach to this quandary has been to develop really quick study habits—picking up, staying attuned to, and understanding the culture, manner-isms, quirks, and interactions that drive business in general and my client's or prospect's business in particular.

This due diligence is essential for a consultant who, in order to be of real value to his or her client, must seek to strike a balance between management vision and market-place reality in the recommendations that he or she makes. That's why it's essential to put yourself in your client's place when making design recommendations. Although you might not think so, your client is not looking to you just for aesthetic solutions; that person or company is looking to you to provide brand-compatible direction in support of clearly defined marketing objectives in every design recommenda-tion you make. The solutions that you come up with must have greater meaning than simply addressing a single issue; to be of real value, they have to integrate seamlessly into the bigger picture if they're to extend brand continuity and build on the client's brand image.

If you work with major clients, chances are you'll be issued a carefully developed set of graphic standards to guide you in the design recommendations you make. When work-ing with smaller clients, it's up to *you* to define and support

design decisions that will work to strengthen brand recognition. If it sounds as though I'm harping on the importance of brand-building throughout this guide, it's only because in today's intensely competitive marketplace, *every* client, large or especially small, is engaged in an ongoing battle to secure market share or otherwise elevate its brand voice—and although you may think of yourself only as a graphic designer, being able to offer design solutions that build on brand image will tremendously increase the value that you bring to your client.

THE IMPORTANCE OF TAKING A WORLDVIEW

While this bit of advice may not seem related to your design practice, believe me, it is. Staying informed means keeping abreast of world and local news events, occurrences within the framework of each client's business, and, of course, design industry events—in that order. You can pretty much assume that your clients or prospects are more comfortable conversing with someone who is well informed on a general, wide-ranging basis than with someone who can speak intelligently only about the design process, a subject that, more often than not, is both foreign and relatively uninteresting to them.

At the risk of repeating myself yet again, some of the best advice I can offer you in establishing a comfort zone with prospective clients is to attempt to put yourself in their

shoes. What that means is getting a sense of where they're coming from in terms of their expectations, being able to identify with their concerns, and being able to offer them assurances that you're the right person for the job. These are some of the things that are just as important as demonstrating your superior design ability.

SELF-PROMOTION

You may recall the self-imposed dilemma I faced earlier in this book in deciding on a new name for my firm: Should it be something generic that would effectively distance me from my business in order to make it look larger than it actually was, or should I connect my name to it and work to build the level of recognition and credibility that clients would embrace because of my direct involvement? In choosing the latter route I knew that I had to establish myself as someone whom clients would feel confident and comfortable with in their decision to entrust me with important assignments. Self-promotion was the answer to convincing my target audience that DanielsDesign was a firm they could count on to provide top-tier creativity without top-tier pricing.

Award shows, published articles, New Year's cards, capabilities brochures, your website, and social media networking represent just a few of the efforts that you'll need to pursue and update on a regular basis in order to build

awareness for your firm. Here are some others and my take on their effectiveness:

The Referral. I think you'll have to agree that hands down, the most effective form of self-promotion is the referral. It carries the most weight because it originates from a source with no particular agenda other than to recommend you as someone with whom they've had a first-rate experience. I've gotten several leads and at least two clients recently through referrals; similarly, I've recommended plenty of qualified professionals to others when I thought they might benefit from the contact. This "business grapevine," as I like to think of it, is based on the reality that each of the contacts we know, whether through work or socially, will likely be linked to others by way of their workplace, their friends or colleagues, their professional associations, previous employment, vendor relationships, or any of a number of other ways that may prove beneficial to you.

Because your name may not be on the tip of your contact's tongue when a referral opportunity arises, there's nothing wrong with planting the suggestion that you'd welcome such referrals. That suggestion can present itself quite naturally in the course of conversation simply by referencing a project solution you came up with—for that person or for someone else. Since so many design and marketing issues are, by their very nature, commonly

shared ones, your work may prompt your contact to recall a similar situation that he or she has heard about from a colleague. That's the opening that allows you to ask if it would be all right to contact that person directly. Truth is, there are many ways of asking for referrals without seeming "pushy." The key is in the relationship you have with your contact and in being able to sense the right time and circumstance to broach the subject.

Networking. While it may fall a notch below a direct referral, many agree that networking offers the best opportunity for selling your services. Whether through informal gatherings or by way of organized business networking, meeting people face-to-face provides you with an opportunity to interact with potential contacts in ways that leave other sales tactics in the dust.

Social networking can occur offhandedly when the subject of marketing or branding—two issues that seem to elicit opinion among just about everyone actively engaged in today's business world—presents itself in the course of conversation. Because being seen as pushing an exchange in one direction or another can rightfully be viewed as self-serving arrogance, I'll ease my thoughts into a discussion either by joining in on dialogue already in progress or by reiterating an event or circumstance that brings some substance to the conversation.

Organized business networking, on the other hand,

refers to those professional groups that regularly sponsor networking opportunities for small-business executives. I happen to be signed up to receive notifications from two of these groups, one run by a prominent business publishing group, and the other by the flagship radio station of a major media network. I have no doubt that there are comparable business organizations in your area (such as your local chamber of commerce) that provide similar opportunities to connect with potential clients.

Wondering how these get-togethers work? From what I've seen, the host organization will settle on a topical theme that it feels will resonate with the greatest number of potential attendees: "Doing Business in Recessionary Times" could be one example. The organization will then arrange for some panelists to host a meeting on this subject and promote it via email alerts both to its membership base and to those people it senses may gain something from attending. The value in taking part in these get-togethers—commonly staged as "small-business breakfasts" so that it won't take too much time away from the normal business day—is in the potentially rewarding contacts that can be made in an informal, mutually supportive setting.

How you profit from these breakfasts is of course up to you; just be sure to bring lots of business cards with you (along with your firm's brochure, if you have one). And should you find that you're not getting enough qual-

ity leads from being a passive guest at these events, you may want to offer to serve on a discussion panel yourself. Think about it: With marketing communications and branding issues foremost on the minds of so many small-business people vying for any edge that will set them apart and above in this very tough economy, your thoughts and counsel will probably be welcomed and rewarded with business opportunities that otherwise might not have come your way.

Believe me, I understand how difficult it can be to pull yourself away from work that always seems to be on deadline or otherwise in need of some level of immediate attention. The trick is in organizing your workload in a way that will afford you the time to become involved in marketing opportunities for your firm.

The Value of Promotional Items. I recall a new project meeting that I had been called to attend at a Fortune 500 client that had come to me by way of a referral from a vendor with whom we both did business. After the formalities of the meeting were completed, my contact, this client's advertising manager, called my attention to a coffee mug he had just received, emblazoned with the logo of a rival design firm. He said it was the latest in a series of monthly promotional gifts that this firm was sending to him in the hopes of garnering an appointment. I really didn't know quite how to react to this show-and-tell; was

he hinting to me that this was expected and I too should be sending him promotional items, or was he letting me know that such excesses were ineffective attempts to gain favor? I responded that the mug and the other promotional items the firm had sent were nice gestures that, while impressive, seemed to have an air of desperation about them. He seemed to agree with my view that such attention-getting promotions held little sway in awarding business. Truth be told, I *was* impressed with these efforts, but it just served to reinforce my conviction regarding the return-on-investment power of a referral versus spending a lot of money on cold marketing approaches that stood little chance of producing the desired response.

Client Gift-Giving. For me, once-a-year gift-giving was another matter; I genuinely wanted to show my appreciation to those clients who had helped to sustain and grow my business over the past year in some tangible (and hopefully memorable) way. This display of gratitude peaked during one particular holiday season at the height of my relationship with Citibank. I had prepared and distributed—by courier—a dozen or so handwoven wicker picnic baskets containing a tin of beluga caviar, a bottle of Dom Pérignon, and two champagne flutes. Appreciated? For sure. Over-the-top? Read on . . .

I really don't think that there's a direct connection between that display of excess and the issuance of policies barring corporate gift-giving, but coincidently, it wasn't

FIGURE 9-1 1995 Holiday Card with Gold
Champagne Bubbles

long thereafter that one by one, large companies began issuing directives to both staffers and vendors alike discouraging the practice. Since then, I've scaled back my expressions of thanks to sending clients the cards and mini-posters that, after four decades, have become a hallmark of my firm (and often take more time to design than most paying projects do).

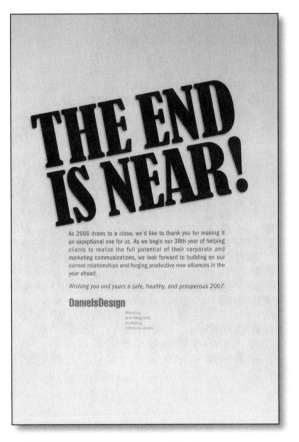

FIGURE 9-2 2006 Holiday Card

I've reproduced a sampling of those cards here (see Figures 9-1, 9-2, and 9-3). Not all of them can be included here because most of the cards and posters employ print techniques (blind embossing, foil stamping, die cuts, unusual substrates, and so forth) that don't lend themselves to monochrome reproduction.

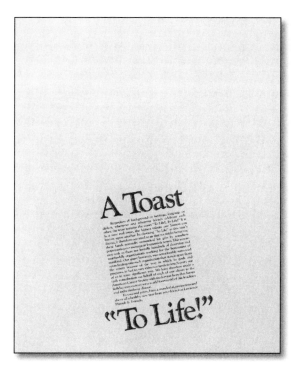

FIGURE 9-3 "Toast to Life" Holiday Card

TESTIMONIALS
Harnessing the power of praise

It goes without saying that if you're getting a consistent flow of repeat business, and you're getting paid fairly and promptly by your clients, that's really all the recognition that you need or should expect—asking a client to *document* the positive aspects of working with you can be uncomfortable at best and audacious at worst. Nevertheless, handled with

care and diplomacy, client testimonials are extremely valuable marketing tools that provide a powerful inducement for prospects to consider the services you offer. After all, the endorsement is coming from your prospect's peer—someone to whom he or she can relate far more readily and with far more confidence and authority than would be possible coming from your own words, website, or sales literature.

Although some of the testimonials I've received over the years have been unsolicited, most have been received by request. So, you're probably thinking, just what is the "right" way to obtain a written testimonial? Well, assuming you enjoy a positive relationship with your client, I would simply ask for it: *"I'm pitching some new business and have given you as a reference. Knowing how busy you are, rather than have the prospect call you, I was hoping you'd be willing to write a short summary of our professional relationship."* I certainly don't make a habit of doing this, but the few times that I have, I've been delightfully surprised with the responses I've received. Obviously, the more influential your contact, the greater his or her credibility is likely to be to your prospect. While I've heard that some companies prohibit this practice, I've yet to run into a roadblock among those clients that I've asked to write a kind word or two.

The bottom line with testimonials is that you can talk all you want about yourself, but nothing can match the credibility and influence you'll reap from peer recognition and client endorsements. Depending on the prospect I'm pitching, I'll usually include copies of one or more relevant (i.e., same

industry and/or same problem) testimonials along with my initial introduction letter and marketing literature (and yes, some were also posted to my website). Take a look at some of the following testimonials I've received over the years. I've included these particular ones because they represent a broad spectrum of clients, assignments, and/or attributes. I've deleted the sender's names and affiliations here, but in practice they are included when I send out actual sales solicitations so that the recipient can check the authenticity of the testimonial, if desired.

> Over the past 20 years, I have engaged the services and worked with scores of graphic design firms on assignments ranging from annual reports, to capabilities brochures, to advertising campaigns, to websites, to full-scale identity programs. During that time I have discovered only two or three design firms whose raw talent, professionalism and personality make them the "right choice" for any assignment. DanielsDesign is at the top of that short list.
>
> What is most notable about their design is its durability. They produce graphic solutions that are neither trendy or pompous; their work looks as fresh and appropriate today is it did when it was created, often years earlier. What is most notable about the firm's professionalism is that they look beyond aesthetic considerations, seeking out strategic and/or communications objectives in an assignment. They read (and often write) copy.

They ask questions. And they design with the client's best interests in mind—their agenda is not simply to win graphic design awards. They earn respect at all levels of an organization, from CEO to stock clerk.

What is most notable about Larry as a person is that he is a joy to work with. He listens. He has a sense of humor. He presents creative and practical solutions, yet he is not territorial about his work. He understands that because design is a subjective discipline, flexibility and compromise are often important aspects of any project. He also happens to be the most organized individual I've ever encountered—in any profession.

I unconditionally recommend the services of Daniels Design to any organization seeking effective design solutions and wishing to avoid the trauma generally associated with that task.

Name

Senior Vice President

Marketing and Communications

Company

For more than a decade [our company] has enlisted the services of DanielsDesign. The firm has taken the time to understand our mission and direction and has helped us to effectively communicate our services and culture to our asset management industry constituents. Larry Daniels is responsive to our needs on both conceptual

and time-sensitive levels, consistently delivering solutions that not only meet but exceed our expectations.

Name

Partner

Company

I've worked with DanielsDesign on a variety of collateral and branding efforts in my position at [company name]. Larry's professionalism is what stands out most in my mind about his work, from the initial review of the assignment to the presentation of the design concepts to the finished piece. No matter how big or small the job, he always gives it his utmost attention and develops solutions that thoughtfully accomplish what needs to be done.

Name

Communications Director

Company

Just a note of appreciation to let you know just how pleased everyone here at [our company] is with the outcome of the [product name]. Thanks to you and your staff on presenting us with a solid, workable design solution; it was the determining factor in meeting our strict production and cost deadlines.

Name

Design Director

Company

I'm pleased to advise you of our decision to accept your proposal to design our upcoming annual report. By far, your proposal and ideas to save us money were the best compared to the estimates and meetings that we had with other design firms. I look forward to working with you and your team and am confident that this collaboration will produce an outstanding annual report.

Name
Communications Specialist
Company

Just a quick note of thanks to you and your staff for all of the hard work and good cheer you've demonstrated in the creation of [this] promotion. In the unrelenting pace of [our company's] projects, appreciation for the contribution of valued resources like DanielsDesign too often goes unspoken. You make us look good and run smoothly.

Name
Vice President
Marketing Communications
Company

DanielsDesign has been instrumental in helping [our association of schools] to reach its goals of creating a clear and compelling identity and establishing straightforward and easily implemented guidelines for its expression.

From the initial brandmark redesign project through the establishment of corporate communication formats and the design of [our] templates and marketing pieces, working with the firm has been a study in creativity and efficiency. DanielsDesign has consistently provided us with attractive, brand-enhancing materials that reflect a clear and thoughtful understanding of the Association's goals, budgets and timelines. The materials they've created have elevated our visibility and increased pride and confidence in the staffers and members who use them. Working with DanielsDesign has been a pleasure and a success!

Name

Conferences & Communications Coordinator

Company

Although from time to time I'd toyed with the idea of following up first-time projects with a short "Client Satisfaction Survey," I haven't taken any steps to actually act on this marketing tactic. Why? Because considering that I'm the client's primary contact, I thought it would be more appropriate to get feedback about a new client's experience either in person or via a phone call. If you feel differently, crafting a short satisfaction survey can be a useful—and often revealing—public relations tool. A survey also provides the perfect opportunity to obliquely ask for a referral and/or request a testimonial. Hint: If you *mail* the survey request, be sure to

leave enough space for the client to write in comments, and remember to enclose a self-addressed, stamped envelope (otherwise, you can forget about ever having it returned).

Here are some of the questions that you may want to include in a client satisfaction survey if you do decide to create one (keep in mind that for single-person design firms and small clients, satisfaction surveys are probably out of place and ill-advised).

Asking your client to write in an answer to each question will likely result in the questionnaire being set aside (too much time to complete) or worse, discarded. You'll likely receive a better response rate by ending each query with simple answers that can quickly be circled, such as "dissatisfied," "as expected," and "exceeded expectations." Be sure to leave an area for comments at the bottom. Questions might include these:

- Did you find us to be well informed and flexible?
- Were scheduling promises met?
- Was the project cost in line with your budget?
- Were you satisfied with our management of outside services?
- Were additions and edits handled promptly?
- Were additions and edits charged for fairly?
- Did we provide direction and counsel as needed?
- Did we interact with your staff adequately?
- Did this project return the results you were promised?
- Will you consider using us on future project assignments?

CAPITALIZING ON PEER RECOGNITION

For most of us, peer recognition means the awards shows. There was a period of time during which I entered almost all of them, and was recognized by many. The net result of that activity was that I have a wall full of impressive-looking framed certificates. If you entertain clients or prospects at your home or office, the awards speak subliminally of your abilities without you having to toot your own horn too loudly. Aside from reinforcing your ego, awards provide great credibility-building tools for your business. You might also want to mention your award-winning capabilities as part of your unique selling proposition (USP) in correspondence, in marketing literature, and on your website.

Design show award winners are generally displayed in a public showing and reproduced in a viewbook. If you have clients that include ad agencies, public relations firms, or others in the communications business, this type of exposure can be a valuable, exploitable resource for you. If, like mine, your contacts work mainly for corporate enterprises, you'll find that most of the organizations sponsoring awards shows will gladly issue duplicate certificates for you to forward to your client(s) with their names appearing on them in addition to yours. I frame and package these certificates along with a note thanking each contact for giving me the opportunity to have worked on the project that won. Nine times out of ten, the framed certificate will

find its way onto the contact's wall, prompting visitors and coworkers to comment on it. What does that do for you, you ask? It's a terrific, inexpensive public relations tool that cements existing relationships and can build new ones for your firm.

On the other side of the coin, there's no denying that preparing show entries can be time consuming and become costly. After many years of active participation, I've lately become very selective in the competitions that I choose to enter. For me, they have to give something tangible back in terms of measurable marketing value. For that reason I now participate only in those shows that I believe will help to reinforce credibility with my target audience.

TAKING THE CHILL OUT OF COLD CALLING

If you're like me and don't enjoy selling in general, it's a sure bet you'll positively *despise* cold calling. If nothing else, it's a very sobering experience—for as talented as you think you are, as recognized as you may be among your peers, you'll quickly (and often shockingly) learn just how much of a nonentity you are among the business community at large.

Still, for all of the "fear factor" trepidation, cold calling (or writing) does seem to have its proponents. One of them happens to be a client of mine, the managing director of a small, successful public relations firm. He actually landed

his firm's single biggest account after reading in the business press about a problem that this particular company was struggling with. My client sent the CEO a cold letter referencing the story and suggesting ways in which his firm might approach the situation. Within days, he was invited in to expand on this "teaser" correspondence. That meeting marked the beginning of an ongoing relationship that in turn has produced other valuable clients for his firm (and by extension, mine too).

I initiate the cold sales process in much the same way because I've seen that it can work. If, for example, I happen to see or hear of some situation—either through the business news media, networking, or other channels—in which I feel I may be able to make a positive contribution, I'll contact the source with an introductory call, letter, or email. My game plan is to (a) reference the basis for initiating the contact, (b) mention our expertise relating to the subject, (c) suggest that I may have an answer to his situation, and (d) offer to meet with the party (without obligation, of course). Obviously, it's presumptuous, irresponsible, and just plain counterproductive to offer any kind of a solution or cost estimate at this juncture.

As an example, here's a letter I sent to the mayor of a small Jersey shore town upon learning that it was considering a name change:

Date

The Honorable (Name)
Mayor of (Name)
Address
City, State, Zip

Dear Mayor (Name),

Having recently learned of the borough's intent to change its name to (new name), I'm sure that you'll be looking at ways in which to correctly position, promote, and ultimately capitalize on this pivotal event. Assuming that the name change is endorsed by referendum, the borough stands at the threshold of reinventing itself to residents, visitors, and the business community. The change presents both a daunting challenge and a unique opportunity, one that must be carefully crafted, conscientiously implemented, and steadily promoted if it is to be successful.

When that time comes, I hope you'll consider DanielsDesign. We're a highly regarded branding and communications design firm providing an unmatched depth of critical thinking and practical problem solving in the planning and development of important corporate and marketing communications tools and programs. With a practiced understanding of the power of perception,

DanielsDesign can help to identify, develop, and position targeted, integrated branding and messaging that speaks with clarity, credibility, and memorability.

The enclosed brochure offers a brief overview of our firm and our approach to solving image-related problems; other examples of our work and workings can be viewed online at (URL). As a shore resident and New York branding professional, I do hope that you'll keep us in mind as the name change effort moves forward. I'll give you a call after you've had a chance to review our qualifications to see when you and your colleagues may care to meet with me to discuss this further.

Sincerely,

(Printed name below full signature)

Unless I sense a level of urgency that would require more immediate action on my part, I generally opt for mailing an introductory letter along with a copy of our firm brochure, some relevant client testimonials, my business card, and a pledge to follow up with a phone call within a week. To ensure that my package won't end up in the round file, I generally opt for the higher cost of sending it via Express Mail,

UPS, or FedEx. This approach almost always generates the attention—and retention—I want when I make my follow-up call.

The other, far more common method of cold calling is telemarketing. This is something that I simply refuse to do myself. I've neither the time nor stomach for this sales approach and would never even have considered it if not for some impressive cold sales calls I received on behalf of a print vendor some time ago. After fielding this telemarketer's third call in as many weeks, I asked whether he worked exclusively for the printing company he was shilling for. Upon learning that he freelanced there, and that he had other clients in the communications field, we worked out a trial arrangement whereby he would work for me one day a week over the course of a three-month period.

From my perspective, the goal of the telemarketing effort was to generate qualified leads that I could then follow up on. I selected a target market in which I had in-depth knowledge and an active client relationship (in this case, a law firm). Next, I outlined strict guidelines relating to selectivity and approach. These parameters included firm size, practice focus, and contact information (in smaller firms, the contact was almost always a name partner; in larger firms, it was the director of practice development or a similar title). We also worked out a weekly reporting schedule in order to review the contacts he'd made to date and to address any issues that he felt might result in better response rates. Because I was

very concerned that if left to his own devices, his approach might turn off some prospects or otherwise devalue my firm in some way, I prepared a script that he could either follow verbatim or (preferably) use as a reference tool. Take a look:

Cold Call Prospect Qualification Parameters for Law Firms

Describe yourself as an account representative for DanielsDesign; make it clear, however, that Larry Daniels will personally attend all appointments.

CATEGORY

White-collar law firms: intellectual property preferred; no personal injury, immigration, landlord/tenant, or debt collection practices.

SIZE

Mid-size preferred: 10–20 partners; 20–30 associates; also, smaller firms with growth potential. No single practitioners.

LOCATION

Manhattan (midtown) preferred; also, tri-state with good potential considered.

CONTACT

Practice development or firm marketing manager/director preferred; secondary contact includes office manager, director of administration, or similar title responsible for firm marketing; may be "partner-in-charge of . . ."

SELL POINTS

DanielsDesign can help law firms to raise visibility, shape perception, and create tangible value for their practice by helping them to recognize and leverage their brand voice. Clients get the benefit of award-winning senior-level communications professionals without the overhead or management layers inherent in larger branding firms.

CASE STUDY

Our ongoing work for (insert a sample client here), an established mid-size intellectual property law firm, includes brand identity development, office signage, creation of a cornerstone capabilities brochure, website development and management, and targeted media planning and advertising (categories: image building, recruitment, licensing, and announcement).

CALL TO ACTION

Top tier:

Immediate need for services—define, refer to DD to arrange appointment date/time.

Middle tier:

Interested in services—refer to DD to arrange appointment date/time or mail info; follow up monthly (or at prospect request).

Bottom tier:

No interest and/or presently working with creative resource—mail info? Follow up? Forget? Determine probability (keep in mind that personnel shifts over time may serve to change situation).

SUGGESTED TELEMARKETING SCRIPT

"Good morning (afternoon)—

This is (your name) of DanielsDesign, a branding and communications design firm. I'd like to speak with the person at your firm who is responsible for marketing or business development."

If the receptionist doesn't seem to understand the nature of your request, cite brochure and website development, advertising, etc. to explain the terms "marketing or business development."

Before being connected, or if you can't get a direct connection at this time, confirm:

- Contact name (correct spelling and phonetic pronunciation, if applicable) title, and direct dial number
- Firm name, spelling, and punctuation; address, floor/suite, zip

If/when you're connected to the right party:

"Good morning/afternoon, Mr./Ms. (name)—

This is (your name) of DanielsDesign, a branding and communications design firm. I thought that you might be interested in seeing some of the work we've developed for a mid-size IP (intellectual property) firm here in New York (see 'facts' below) and learning more about the ways in which we may be able to assist your firm's branding and marketing efforts."

If yes, set up a tentative meeting time subject to confirmation; more likely, the contact will ask that you send some information about DanielsDesign for review:

"I'd be happy send you our firm brochure and samples of our work for some of the other firms we've helped. Let me just confirm the mailing information that I have

(repeat above; adjust if necessary).

I'll give you a call after you've had a chance to look over our material to see when you'd like to get together with Mr. Daniels."

If not interested, try to assess why. Keeping in mind that situations change over time, make a judgment call as to receptivity and follow-up:

"Thank you for your time. I'll call back in (number of weeks, months) to see whether your current needs have changed."

or

"Thank you for your time. I'll call back on (specific date) to see when you'd be available to meet with Mr. Daniels."

REFERENCE FACTS

CLIENT: Amster, Rothstein & Ebenstein (also Garson, DeCorato & Cohen and Goldberg & Connolly)

SIZE: Mid-size intellectual property law firm of 45 partners and associates

WORK: Brand identity and implementation (stationery, office signage, marketing materials)

Advertising (we serve as AR&E's "agency of record" for media planning, ad creation, placement, and tracking)

Website development and maintenance

Themed special events planning/coordination

Also, you might want to mention that our brochure highlights examples of our problem-solving branding and marketing approach applied to many other DanielsDesign clients.

Keep notes on each contact for follow-up.

While my arrangement with this telemarketer did result in some appointments, it didn't produce either the quantity or quality of results that I had hoped for. For me, the letter introduction approach worked far more successfully than the

telemarketing did; perhaps your efforts will produce a more positive response. In my case, I'm guessing that probably because the letter method referenced a specific, timely issue instead of just offering a generic profile of my capabilities, it was more relevant to the recipient. In any event, if you'd like to try telemarketing, you might want to use the outline I've provided as a model in crafting your own audience-specific script.

PROMOTIONAL MARKETING

Over the years, I've done a fair share of promotional marketing that including the firm's New Year's cards, its capabilities brochures, moving announcements, media advertising, trade show participation, and of course its website (since taken down, in case you're looking). Here's a brief summary of how each of these efforts have stacked up for me:

New Year's Cards. Taking on a wide variety of themes and graphic treatments, this once-a-year messaging has allowed me the creative freedom to express a broad range of styles and sentiments (almost always seasonal; never directly holiday related) without having to adhere to any of the limits imposed in commissioned work. Because I realized from the very first one that the cards would be viewed as a litmus test of the creativity that the firm had actively promoted, they were in a very real sense some

of the most difficult projects to design—and at the same time, some of the most satisfying. In terms of effectiveness, from the responses they've garnered over the years, I'd have to say that the cards not only reinforced the creativity claims I've made, but they also served as effective vehicles for staying in touch with clients, prospects, and colleagues, both past and present. As an added bonus, they also earned me quite a few more awards to display.

Capabilities Brochures. As noted earlier in this guide, I believe that being able to send and/or leave behind a brochure that's composed of a sales pitch and a few diverse examples of your work product (citing the logic behind each example's development), as well as a client listing and contact information, rates as an essential, indispensable sales tool that you really shouldn't do without. If updating and/or print costs are a strain on your resources, you might want to consider composing and outputting separate sheets that highlight just a few key examples of your work, client listings, testimonials, and so forth, presenting them in the pocket folder we discussed in Chapter 6.

Moving Announcements. In the forty years I've run my business, I've moved a total of seven times, five of them to larger, more prestigious, better-equipped office space. Each successive move provided me with a unique

opportunity to let both clients and prospects know how and where they could now reach me and why the move represented another step up as a full-service design firm. As with the development of all in-house promotional pieces, the announcements also provided an opportunity to reinforce our core capabilities through design.

Advertising. From time to time, I've engaged in three types of limited trade advertising via two basic media channels: design magazines and publications targeting specific business demographics.

The only reason I ran advertising aimed at the design community was to build awareness; I didn't really expect much in the way of direct sales coming from this exposure and I certainly wasn't disappointed on that front. The positive result of that effort was receiving job applications from some very talented people; the ads also provided the recall I was seeking among contacts within the marketing departments of several of the prospect companies I was targeting. The negative side of that coin was the large number of vendors who also came calling.

In contrast, ads run in trade journals aimed at specific audience groups *were* designed to provide me with new sales leads. The headlines and opening paragraphs of each ad in that series referenced our expertise in each particular market that I was targeting, followed by brief

call-to-action copy. Although I did pick up some new business in this way, I felt that the quality of the relationships (most became "one shot" clients) didn't ultimately justify the cost of the advertising. Also, because the ads reached a broader geographic area than I was accustomed to serving, it was important for me to get a real sense of project scope and budget—something that is usually never my first topic of conversation with new business possibilities—before committing to traveling to these far-flung prospects.

The third type of B2B advertising I've engaged in from time to time can best be described as generic, that is, promoting our branding and design services to a broad range of general business venues likely to have a need for the creative services we're able to provide. The media of choice for me here was *Crain's New York Business,* a respected publisher targeting mostly small to mid-size businesses. The ad I placed is shown in Figure 9-4. Here again, I felt that the response was scattershot and generally tepid in terms of connecting with solid leads. While I don't regret having gone this route, the response certainly didn't meet my expectations.

Trade Shows. The venue (the NY Hilton) and sponsorship (Advertising Trade Publications) of this three-day event had promised a large gathering of potential clients, and the turnout didn't disappoint in terms of the actual num-

If it's not communicating a consistent and relevant personality in today's fast-paced, oversaturated business environment, it simply isn't doing its job.

What message is your firm's marketing sending to important audiences?

DanielsDesign can identify and leverage your firm's unique attributes into a strong and influential brand voice that can help raise visibility, shape perception, and reinforce credibility with target audiences.

Call Larry Daniels directly at **212 681.0844** for a no-obligation consultation and to learn more about the ways in which we may be able to strengthen your firm's marketplace presence by design.

DanielsDesign

Branding and communications design

DanielsDesignNY.com

FIGURE 9-4 Generic B2B Ad

ber of attendees. As for connecting with new business, what little of it I secured proved to be an economic wash; it paid for the booth and accompanying display graphics and handouts, but not much else. As expected, we were visited by far more vendors and job seekers than potential clients. In sum, I'd say that trade shows can be a good way to connect with a large number of business colleagues if you can spare the time and cost needed to participate in them.

Another thing to consider: Trade shows require that your display be manned for the duration of the event. For a one- or two-person firm, the time necessary to physically be in attendance—especially when the bulk of visitors to your site are looking for freebies—can be counterproductive and maddening, especially if you have billable, time-sensitive work back at the office that requires your attention.

Websites. This of course is a no-brainer. There's really no question that having a website to showcase your capabilities is an absolute must for a design firm. You'll recall that my take on website design and content was covered in Chapter 4 of this guide; suffice it to say that without a well-executed presence on the web, you might as well close up shop—that's how important this marketing tool has become for businesses in general and especially for the design community. With website design, develop-

ment, and updating accounting for an ever greater share of revenue for design firms large and small, it's critical that your own site project a carefully planned and crafted image, one that sets you apart from your peers and communicates the levels of creativity, analytical thinking, problem solving, and proficiency necessary to influence your intended audience—a tall order when you consider that every other design firm creates its site along the same set of parameters.

Social Media. The explosion in social media has changed the rules for marketing yourself and your firm. For the small-business entrepreneur who is already stretched thin with the myriad details that require day in and day out attention, making time for social media marketing requires discipline and selectivity. Leveraging your brand regularly through the most appropriate channels is essential to building the most visibility and credibility for your business. Obviously, the sites that your clients and prospects use will make the most sense for you to join. Seeing where your clicks are coming from makes it easy for you to focus your efforts on those venues that will be most effective for you. Aside from posting your qualifications, the key to getting the most from social media is to engage interactively with colleagues and other professionals within your sphere of influence through the many blogs and discussion groups run by several of the most popular sites.

My intent in preparing this summary was to briefly encapsulate my experiences with each of these marketing venues in order to help inform the promotional choices you make for your business.

There is one other thing to keep in mind when it comes to marketing your firm: Remember that *you* are your own publicity agent. Set aside the time to promote your business in ways that build awareness, recognition, and credibility for you and your firm. Beyond the marketing venues touched on here, there are many other indirect ways to build your reputation—both as a good designer and as a good citizen. Some of these include serving on a community board, mentoring, volunteering, and taking on pro bono work. These unselfish interactions on your part can frequently lead to important (and often lucrative) connections for your business.

By the way, when I mention pro bono work, I don't mean spec work, which is almost *always* a bad idea. Being lured into submitting your ideas without compensation based on the promise of possible work degrades your value as a designer and as a business professional. Bona fide clients wishing to compare creative approaches to a problem in lieu of awarding assignments will almost always set aside a stipend for each firm they invite to participate in the pitch.

My firm took up such a challenge from New York Road Runners on three occasions to come up with a branded theme for that year's marathon. We lost one and won two. The stipend of $5,000 that was set aside for each invited firm was

fair and evenhanded—and while that first loss was certainly disappointing, the stipend covered the time we had expended in preparing and submitting our concepts. The years that we won, however, that stipend represented only a fraction of the overall budget allocated for developing the myriad of marketing materials needed to promote this legendary event.

Returning to the issue of pro bono work, when I finally became infuriated and impassioned enough at what I saw as a flagrant disregard for ordinances banning public littering in my adopted "garden" state of New Jersey, I took it upon myself—both as a designer and as a fed-up citizen—to organize and promote an anti-littering campaign (which, as of this writing, is still "under consideration"). The prototype public service ad I designed (Figure 9-5) was intended as a rallying cry for bringing awareness and action to the problem.

Whatever forms your promotional efforts may take, be they materialistic or altruistic, It's important to remember that in order to be effective, they must always be focused on building and reinforcing the image that you want people to have of you. Certainly, the bulk of that image centers on your design ability. But to a lesser degree it also comprises an amalgam of other character traits—your demeanor, your problem-solving abilities, your integrity, your flexibility, your business acumen, and your responsiveness—qualities that contribute to an overall impression of who you are and whether you can be trusted to deliver on the promises that you make.

TOGETHER, WE CAN TURN NEW JERSEY BACK INTO THE GARDEN STATE

Look around: Trash. Litter. Filth. You see it everywhere. On our roads. In our towns. On our beaches. And it sends a clear message to residents and visitors alike. If New Jerseyans don't take pride in their state, why should anyone else?

The sad truth is, *comedians* do care. Time and again, they make New Jersey the butt of jokes. Jokes that should serve as a shrill wake-up call: Either live up to our state motto or sit by and watch as New Jersey continues to be dumped on. By comedians. By politicians. By the media. By visitors. And sadly, by some residents.

It's no laughing matter. Our ability to attract new business and new residents affect our property values, and in turn our tax base. If you're ready to turn New Jersey from *The Garbage State* back into The Garden State again, we can show you how you can make a real difference. Simply and effectively, starting now.

Please call your concerned neighbors at 973 000-0000 or visit us on the web at www.newnewjersey.org to learn how you can become an important part of this grassroots effort.

The New New Jersey
For Work. For Play. For Keeps.

Prepared by DanielsDesign Inc.

FIGURE 9-5 Pro Bono Ad Prototype

AVOIDING THE "EGGS IN ONE BASKET" PREDICAMENT

Back when the lion's share of my revenue came from designing book jackets, a contact of mine at a publishing client changed jobs, shifting 180 degrees into the financial services industry—an industry in which I had little practical experience and precious little knowledge. That job change, however, was to be my awakening, my growth engine, and, as you'll read, nearly my downfall. The "awakening" part came upon my discovery of the potential of this explosive industry for my fledging firm. The position this contact accepted was that of a product manager at a major consumer bank. After starting off with small "test" assignments to gauge my "fit" within this buttoned-down organization, I was steadily awarded more visible projects that in turn were seen and noted by my contact's colleagues in other departments at this banking giant.

Some two years into this ever-expanding relationship, I found that it became nearly impossible for me to accept work from other clients or, for that matter, spend any time prospecting. While intellectually I was aware of the "eggs in one basket" syndrome, there seemed little I could do to avoid it. Work was pouring in from multiple sources at the bank, and turning down an assignment was an open invitation for that product manager to seek other creative sources (and believe me, firms large and small were tripping all over themselves to get a slice of this prestigious and lucrative pie).

Although by now I had hired staff to help me handle the workload, my concern over every aspect of every assignment (some might rightfully call it micromanaging) effectively precluded me from tending to other aspects of longer-term business growth that I knew I was neglecting. To compound matters, by now several of the product managers I was working with had received promotions to either associate or full department vice presidents. This new clout only served to further strengthen my presence within the organization. From a financial standpoint, my little firm had finally made it into the big time—but at a price. I found myself working day and night to fulfill ever more demanding project obligations on schedule, a schedule that never seemed to be completed.

And then, seemingly without warning from my overworked viewpoint, came the market crash of 1987. Financial services companies large and small, consumer and boutique, either downsized, reorganized, or simply folded. My client responded to the crash by eliminating some 4,000 positions on what euphemistically came to be known as "Black Friday" at the bank. To make matters worse—for me, at least—most of those eliminated positions were attached to marketing-related functions. Within weeks it became frighteningly clear that nearly all of my valued contacts were gone from the bank, and the steady flow of work they had provided had all but dried up. A decision had been made at the most senior levels of the bank that even the smallest collateral assignments were to be consolidated under

the umbrella of their one remaining ad agency. Many of the contacts that I had carefully cultivated suddenly found themselves standing in unemployment lines. Obviously, it would be some time—if ever—before I would be able to reach out to them again. And although I scrambled madly to maintain a decent work flow, the writing was indelibly etched on the wall. Because I had neglected new business sales, a disproportionate percentage of my operation was tied up with the bank.

To make matters even worse, several of my other active clients were also tied into financial services—picked up as referrals from some of the many contacts I had made in that industry. One of those clients, a relatively small asset management firm, had me working with its marketing manager, who also happened to be a licensed stockbroker. Because of the amount of business that I was doing with this client, I felt an obligation to open a trading account with the firm. With what I should've seen as a disturbing trend, I would regularly receive phone calls from this contact advising me to buy a couple of hundred shares of this stock or that one. Whenever I would question his counsel, I would receive flip answers that at the same time contained undeniable truths. Let me give you a paraphrased example:

HIM: "Larry, I want to put you into 200 shares of Waste Management."

ME: "What can you tell me about this company, Mark?"

HIM: "You read the papers; the country is drowning in
 garbage; they make more of it every day."
ME: "Hmmm . . . guess I can't argue that logic."

As I said, I really didn't want to tip over the apple cart with this client, as the firm was a prompt payer that did a lot of business with me. That is, of course, until the crash. Within days, it seems, the firm went belly-up and I was left holding a bunch of near-worthless buy and sell orders. Knowing that he had me between a rock and a hard place, the marketing manager had been churning my account, collecting commissions on each transaction he placed. I quickly sold off what I could, taking a beating that took a long time to recover from.

With all that was going on, my sense of commitment to my employees and my ever-optimistic outlook that things would soon turn around resulted in my waiting far too long to downsize my firm. With no positive cash flow on the horizon, I was finally faced with no choice but to let all four of them go at once, scraping the bottom of my ever-dwindling bank account to pay out fully vested pension and profit-sharing plans and recurring, ever-mounting debt.

It was then I resolved that if I were to somehow find my way out of this mess, I would do four things differently:

1. I would rebalance priorities in terms of work vs. selling.
2. I would never again fall into the "too comfortable/too confident" trap.

3. I would work on building strategic alliances with skilled creative resources and vendors in place of salaried staffing.
4. I would never again trust my assets to a brokerage house.

I'm happy to report that taking my own advice turned out to be the right thing to do in the years since that time. I urge you to follow my lead when it comes to both client diversification and nest-egg building.

First, as committed as you may be to the success of your business, always, *always* separate your personal and business finances. When I mentioned "scraping the bottom of my bank account," I was referring to my business account. Tapping into your nest egg is a risky proposition that can seriously jeopardize your personal credit standing and long-term financial security.

Next, unless you feel absolutely confident in your ability to take on the often complex, ever-shifting landscape of financial planning, I would enthusiastically urge you to engage an independent wealth management professional to help you appraise your current situation and structure a long-term investment program for you, one that will see you through to a comfortable, worry-free retirement.

I know, I know—the thought of retirement may be a long way off, but without the structure of forced savings and possibly matching corporate contributions that you'd probably be required to participate in were you working for a large

employer, it's easy to see how a self-administered program can quickly go astray—especially in light of the inevitable course of roller-coaster jumps and dips inherent in this quirky business of ours, instability that can quickly derail even the most well-intended planning.

The professional I use has an MBA, is a CFP (Certified Financial Planner), works independently of large, often impersonal asset management firms, and has no hidden agendas to push securities or any other "get rich quick" investments on me. In the twenty-plus years since deciding to go that route, the slow and steady gains I've made have given me the security I need to stabilize and methodically grow my asset base.

Okay—I realize that I have gotten off track here, but I know that you'll benefit from heeding my advice on the personal financial front. Now let's segue back to the "selling your services" issues.

10

GROWING YOUR FIRM IN ANY ECONOMIC CLIMATE

"WE" vs. "ME"
The art of shaping perception

Whether I've employed staff or hired freelancers, I've always opted for the "we" approach—a positioning strategy that I know has helped me land clients and projects generally considered approachable only by much larger firms. Once you've made the decision to market your business as a "we," understand that in doing so you've now obligated yourself to support that position constantly and consistently—not only in written and verbal communications as discussed in Chap-

ter 6, but in *every* aspect of your business: its location, its marketing materials, its management, and, of course, its end product. It means committing to establishing and reinforcing a totally professional persona in everything associated with your firm.

What it does *not* mean is affecting a "creative type" image. That kind of sophomoric posturing marks you as aloof, inflexible, and generally disconnected from the very people you look to—and who look to you—as a resource and partner in the creative process.

Conversely, what it *does* mean is viewing your relationship with your client from his or her perspective—by understanding that initially at least, you've been selected largely on faith. Whether that faith was a result of a referral, a compelling presentation, a job shift, or other circumstances, it's important to understand that your client is exhibiting an exceptional level of confidence in his or her own decision-making ability, confidence that, depending on the outcome of each and every assignment entrusted to you, has the potential to spell either success or failure for *both* of you. For you, it can mean either the beginning of a promising long-term relationship or losing a first-time client; for your contact, it can mean either gaining stature within the company for getting the job done right or risking losing the support of his or her superiors.

LEVELING THE PLAYING FIELD

In terms of industry reality, only a handful of design firms employ more than twenty (or, for that matter, even ten) people. The vast majority of firms are one- to five-person operations. Thanks to the Macintosh computer, the design software written for it, and the proficiency of the designers and production people using it, much of the graphic design playing field has now been leveled to a point at which it's often impossible to differentiate the quality of work coming from large firms or small operations. The raw talent and mastery of materials that once produced stunning marker comps and intricate pen-and-ink work are now long gone—replaced by programs that can do these things far more realistically, more efficiently, with more options, and at lower cost than even the most seasoned professional could ever have thought attainable.

And so the question begs: With all this homogeneous software available to anyone proficient enough to capitalize on its full potential, what is it that will convincingly separate one design firm from another? The fact is, there remains an enormous gap—and therefore an enormous opportunity—for even the smallest firm to break out of the "freelancer" mode and take advantage of the way in which clients are approached, projects are undertaken, and deliverables are managed: That opportunity is in the way you approach the branding and marketing of your firm.

Designers who go out on their own often fail to understand this fundamental reality of design business operations: that regardless of size, the successful firm is made up of several competencies, touch points that seemingly have little to do with the design process per se. And that each of those building blocks combine on each and every project to establish a comfort (or *dis*comfort) level that, for better or for worse, will have a far-reaching impact on how your firm is perceived—and in turn, how it will stand to prosper in this very competitive field during these very competitive times.

In essence, the amalgam of impressions that leads up to the way in which your firm is perceived is really the core definition of "branding"—a concept that, unfortunately, is not readily understood by designers, who too often see branding as simply having an attractive logo applied artfully.

Always remind yourself that the way in which you represent yourself and your firm to your publics will pretty much determine the level and quality of business that you can realistically expect to acquire. It's important to remember that for better or worse, perception shapes reality.

CORPORATE CHEMISTRY
Adapting to cultures and personalities

In business terms, "chemistry" refers to that all-important, underlying bond that inevitably will make or break a professional relationship. If that sentence reads as if it should be

coming more from a dating service than from a design firm business guide, there's good reason for it: When you think about it, the two situations are actually quite similar. Beyond your competence as a designer, factors such as appearance, mannerisms, professionalism, enthusiasm, and amiability are among the other character traits that play a part in establishing and sustaining a successful business alliance.

To some degree, of course, these are qualities that are not teachable; they're simply a reflection of who you are. 'Truth is, you're never going to be all things to all people anyway, so my advice to you is to not even bother trying to reinvent yourself into someone you're clearly not. What I think you *can* and *should* try to do is adapt your personality only to the degree to which you're still comfortable with the image you're projecting. There will always be those people you'll connect with and those you won't. That's just the nature of human interrelationships.

As anyone who has been in this business long enough can readily affirm, a great relationship with a client can turn from hot to cold pretty quickly through no fault of either party. Take, for instance, a common business situation that often occurs when a new person is brought onboard your client's organization—someone with whom you're expected to interact but for one reason or another you find that you simply can't. Of course, it could just be that the chemistry between you is incompatible, but it's more likely (this from my personal experience) that this new person has previously

worked with a design resource that he or she is entirely comfortable with. Since it's probable that you don't have any long-term contractual agreement with your client, you have a finite amount of time to either prove your worth to this new party or try to develop other relationships within the company.

It's important to accept the fact that regardless of how valuable you think you are to your client, you're still an outside resource, not privy to those day-to-day workings and decision-making processes that can quickly (and often irreversibly) change the course of your relationships within an organization.

If you see the writing on the wall, my advice to you is to try to gently mine information from your primary contact—either at lunch or anywhere else *away* from the office setting. Reasonably "loosened up" (yes, alcohol is a great lubricant), you may actually discover that the new person may be squeezing your contact out the door as well. Handled with empathy, that informal get-together may serve as the very catalyst you need to really cement your relationship with your original contact so that you'll be on the "first call" list wherever he or she eventually lands.

HOOKING THE BIG FISH

Here's a reality check: Unless you're fortunate enough to have a friend, colleague, or family member able to introduce

you to otherwise out-of-reach, over-the-top clients, the like-lihood of your ever getting your foot in the door of a major player "cold" is remote at best. Yet without a few prestigious corporate clients on your roster, breaking into the big leagues will likely remain a pipe dream in spite of your talent level or professionalism.

In large measure, I was able to break out of that "catch-22" situation by way of two important affiliations that I made early on. I think you may find these experiences to be valuable guideposts in cultivating and expanding your own business opportunities.

You may recall from Chapter 2 how my relationship with a print vendor led me to a friend of his at the American Stock Exchange. That introduction not only resulted in a new and prestigious client for my business, but also led to my meet-ing and working with a marketing manager at the Exchange who, shortly thereafter, left to start his own financial public relations firm. Because we had worked so well together at the Exchange, this person informally asked that I serve as his "in-house" design resource. The beauty of our relationship was that I was able to maintain my autonomy as an inde-pendent design firm, billing his (and now also, my) clients directly for the work I was engaged to perform. The depth of this association extended well beyond the customary client/vendor connection, as I was often invited to accompany him on client meetings and new business pitches. These face-to-face corporate encounters did much to establish an ongoing

relationship with the client or prospect, deepen my under-standing and appreciation of business practices in general, and allow for firsthand insights into whatever problem I was being retained to examine.

The second scenario I'd like to relate to you occurred when I was introduced to a senior partner at the New York office of a global human resources consulting firm, a firm whose clients all ranked within the Fortune 500. There's no question that those client contacts would've been far beyond my reach had I attempted to solicit them on my own.

Charged with developing its own creative resources, this regional office—just like my arrangement with the PR contact—offered me the opportunity to serve as the creative intermediary between the HR firm and its clients. Better still, once my initial introduction to that firm's clients was made, all subsequent dealings with them was direct, resulting in some very satisfying (and lucrative) long-term relationships, relationships that resulted in my firm being assigned proj-ects often far afield from the work I was originally brought in to do.

As you would expect, the work products developed as a result of these relationships, along with the industry-specific knowledge gained in working with this diverse group of cli-ents, combined to provide me with a strong and compelling foundation for soliciting new business from other HR firms. There was never a noncompete clause in any of my relation-ships with any of these consulting firms; in fact, the other

firms genuinely seemed to embrace the fact that I was able to put the experience I had acquired to work for *their* client base.

MINING THE MEDIA

A great way to extend your influence, and in turn grow your business, is to write a column (or blog) focused on your particular area of expertise. The Q&A format is ideal because after the first couple of broad-appeal, self-generated questions and answers, subsequent queries will likely come from interested (and potentially valuable) readers.

While anyone can start a blog, connecting with a publication carries an added bonus of prestige, credibility, and, most important, a ready-made audience. I've found that local or regional business publications are generally the most receptive venues for pitching your concept, especially if the following four benchmarks are met: (1) the proposed column or blog speaks to a need among the publication's constituency, (2) you're a decent writer, (3) you're able to demonstrate expertise in your subject, and (4) you offer your services without cost to the publication. Having researched likely outlets for my proposed column, I sent out a pitch letter and prototype column (Figure 10-1 on page 199). If you try this approach, be sure to include a copyright notice to protect your work. Although copyright is automatically secured when your work is created, there are certain advantages to

registration (for more information, visit the U.S. Copyright Office website at www.copyright.gov).

Take a look:

Proposal to Write a Q&A "Branding" Advice Column for (Publication Name)

ADDING BUSINESS CREDIBILITY TO A SUCCESSFUL MAGAZINE FORMAT

(Publication name's) target demographic strongly suggests that its audience includes a large number of regional business leaders: executives directly responsible for key management decisions relating to the ways in which their companies, products, and/or services are perceived. While it's readily acknowledged that perception is shaped by correct and consistent brand positioning, branding is an area that's all too often undervalued or misunderstood as a strategic marketing tool by small and mid-size companies vying to compete in today's cutthroat business environment.

Although several B2B journals regularly touch on this important issue, I think you'll agree that many of your readers would appreciate a Q&A column specific to the brand-related issues that they face.

WHY YOU NEED THIS COLUMN

Far more than a buzzword or simple cosmetic fix, branding is one of today's most potent marketing tools for building awareness, customer loyalty, and, ultimately, sales. Successful branding can create a "first call" mentality that can put a business at the forefront of customers' minds to provide a given standard of value, reliability, and overall excellence—setting that business apart from its competition and providing a comfort level that customers can solidly identify with.

Building that level of brand loyalty demands a single-minded vision of the core business mission—exploring questions of who you are, what you stand for, and why customers should place their faith in the products or services you sell. Establishing a correct and consistent brand image and voice is an essential component of the overall business mix—one that's become especially critical for small and mid-range companies scrambling to find an edge they can build upon.

The column I'm proposing will seek to address brand-related questions that bear direct relevance to this audience. Your publication's monthly frequency will allow me the time to dispense informative, enlightening guidance that businesspeople of all stripes and all sizes may be able to effectively apply to their own situations.

ABOUT THE WRITER

Larry is the president of DanielsDesign Inc, a highly regarded branding and design firm dispensing an unmatched balance of critical thinking and practical problem solving in the planning and development of a broad range of strategic corporate and marketing communications tools and programs.

Since its inception, DanielsDesign has created and managed comprehensive branding programs for large corporations (e.g., Travelers Insurance) and organizations (e.g., Girl Scouts of the USA) as well as for start-ups. The firm focuses on providing design-based, major market solutions to businesses seeking to identify and leverage their unique culture and attributes into a strong and influential brand voice in order to raise visibility, shape perception, and reinforce credibility with target audiences.

REVIEW THE PROTOTYPE COLUMN

I've attached a prototype column for your consideration. In lieu of generating actual reader participation, I can begin the column by posting some of the many brand-related questions that have been asked of me over the years.

I hope you'll agree that a fit exists for such a column. I look forward to hearing from you and to working with you in bringing *Ask the Brand Doctor* to fruition.

Sincerely,

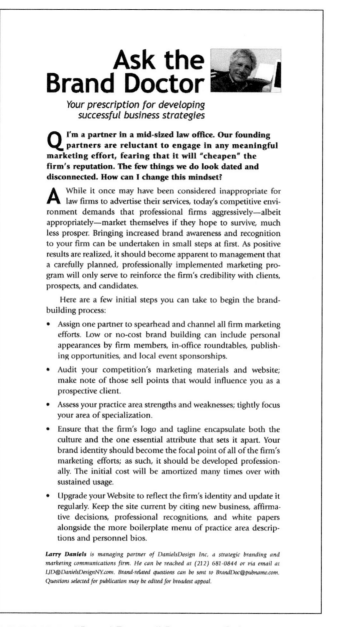

Ask the Brand Doctor

*Your prescription for developing
successful business strategies*

Q I'm a partner in a mid-sized law office. Our founding partners are reluctant to engage in any meaningful marketing effort, fearing that it will "cheapen" the firm's reputation. The few things we do look dated and disconnected. How can I change this mindset?

A While it once may have been considered inappropriate for law firms to advertise their services, today's competitive environment demands that professional firms aggressively—albeit appropriately—market themselves if they hope to survive, much less prosper. Bringing increased brand awareness and recognition to your firm can be undertaken in small steps at first. As positive results are realized, it should become apparent to management that a carefully planned, professionally implemented marketing program will only serve to reinforce the firm's credibility with clients, prospects, and candidates.

Here are a few initial steps you can take to begin the brand-building process:

- Assign one partner to spearhead and channel all firm marketing efforts. Low or no-cost brand building can include personal appearances by firm members, in-office roundtables, publishing opportunities, and local event sponsorships.

- Audit your competition's marketing materials and website; make note of those sell points that would influence you as a prospective client.

- Assess your practice area strengths and weaknesses; tightly focus your area of specialization.

- Ensure that the firm's logo and tagline encapsulate both the culture and the one essential attribute that sets it apart. Your brand identity should become the focal point of all of the firm's marketing efforts; as such, it should be developed professionally. The initial cost will be amortized many times over with sustained usage.

- Upgrade your Website to reflect the firm's identity and update it regularly. Keep the site current by citing new business, affirmative decisions, professional recognitions, and white papers alongside the more boilerplate menu of practice area descriptions and personnel bios.

__Larry Daniels__ is managing partner of DanielsDesign Inc, a strategic branding and marketing communications firm. He can be reached at (212) 681-0844 or via email at LJD@DanielsDesignNY.com. Brand-related questions can be sent to BrandDoc@pubname.com. Questions selected for publication may be edited for broadest appeal.

FIGURE 10-1 "Brand Doctor" Prototype Column

MINING OTHER INCOME STREAMS

In Chapter 8 we discussed the reality of dealing with down-time and some of the things you need to do in order to satisfy those other aspects of your business that vie for attention—including taking some time for yourself and your family. We also discussed how staying attuned to other diverse opportunities in the business world might provide a window for *creating* new opportunities for your firm.

You'll also recall from Chapter 9 the "cold call" letter I had sent to the mayor of a town offering my firm's services in connection with his borough's name change. Responding to a news item when your ideas and expertise may prove to be of value can sometimes provide the opening you need to pitch new business for your firm—and opportunities can come from anywhere. Consider this:

When I picked up a copy of *Fortune* magazine in my dentist's waiting room some time ago, I noticed a story about the Zippo company's quest for new product lines to ignite (pun intended) stagnant sales. It seems that with more and more people giving up smoking, sales of the company's lighters were flatlining, causing employees and equipment to sit idle. Giving this dilemma some thought, I realized that an ideal situation for the company might be for it to develop a new product line that would generate excitement among a younger demographic using existing equipment so that retooling expenses could be kept to a minimum.

Introducing

HEAT

A hot new fragrance line concept developed by DanielsDesign
for market consideration by Zippo Manufacturing Company

THE PRODUCT

Heat is proposed as a new line of fragrances aimed specifically at the trend-obsessed teen marketplace. Its unique scents and especially its packaging and presentation will combine to make it a 'must-have' item for both guys and girls.

THE FRAGRANCES

I envision an initial offering of 'freshscents' in four distinct fragrances for guys, girls. Scents will be formulated to complement specific moods and situations, i.e. *Heatzone 78, 82, 86, 90, etc.*

THE PACKAGING

Based on the look, size, feel, and cachet of the Zippo lighter, *Heat* packaging will be offered in both regular and slim versions in a variety of unique, gender-appropriate finishes:

For guys
Brushed silver, machined silver, silver/turquoise, matte black

For girls
Brushed gold, polished gold, silver/gold accent, silver/turquoise

In addition, both styles would be made available with monogramming, making it a unique, compelling, and affordable gift. The fragrance vials are envisioned as replacable glass or plastic pump-type insets that may be interchanged as the mood or situation dictates. Built around the pump mechanism will be a 'windscreen' fabrication aimed at complementing the cache of the Zippo lighter.

I envision *Heat* being sold individually or in sets containing a selected case size and finish plus four fragrance insets.

THE MARKETING

The appeal potential to this formidable market segment will be to present *Heat* as a must-have item: its look, its variety, its affordability, and perhaps most importantly, its cachet must simply and succinctly say:

HEAT IS HOT. HEAT IS COOL.

That overriding theme can be brought home in a number of ways: product and package design, typography, color, and materials will play a defining role; advertising and point-of purchase can easily pick up a powerful theme based on the name and physical properties of the product itself:

'Turn Up The Heat', 'Chemical Reaction', 'Pocket Furnace', 'Pack Some Heat', 'Chill With Heat', 'Smokin', 'The Perfect Match', etc.

Effective media outlets for this product abound: Teen magazines, MTV, billboards, personality endorsements, in-store promotions, and of course word-of-mouth can help propel *Heat* to new heights.

ABOUT DANIELSDESIGN

Since 1969 DanielsDesign has been an influential presence in branding and communications design. Its principal, Larry Daniels, is the recipient of virtually every professional industry recognition and continues as the firm's guiding force. Although *Heat* is a first for him in terms of product development, it should be noted that Larry quite literally grew up in the eye of the fragrance industry: his father was a noted cosmetic chemist who developed product lines for Germaine Montiel and several other companies during his professional career. In addition, DanielsDesign served as the advertising and promotional agency for Orjene, a leading natural cosmetic manufacturer for a four-year period, developing packaging and marketing concepts and creating advertising aimed at positioning this established resource beyond its niche markets.

I welcome your interest and look forward to working with you
in helping to develop, market, and launch *Heat.*

FIGURE 10-2 "Heat" Concept Proposal

FIGURE 10-3 "Heat" Prototype Packaging

In Figure 10–2 on the previous page you'll see the concept I presented to the company. Visual product and packaging representations are shown in Figure 10–3.

Along with this proposal—and for that matter, along with any alternate income stream idea I submit—I included a brief bio citing my background and qualifications for developing and implementing the concept I was submitting.

Prior to sending off *any* unsolicited proposition, I make certain that I have a signed nondisclosure agreement in hand. Read on.

THE NONDISCLOSURE AGREEMENT

The Confidential Disclosure Agreement is intended to protect your idea from being appropriated without acknowledgment or compensation. Although not legally airtight (your

concept can easily "fall" into the hands of someone other than the signatory even though the agreement specifically addresses this issue), it is a generally accepted means by which to submit and protect your idea. Should your concept be implemented without your knowledge or involvement, the signed agreement at least provides the "legs" you'll need in order to pursue a course of legal action. This agreement model is just an example. Although it served my purpose, you may wish to consult a lawyer concerning particulars of the idea(s) you intend to submit.

CONFIDENTIAL DISCLOSURE AGREEMENT regarding the transfer of a marketing concept to be disclosed by (your name) a/k/a "provider" to (prospect name) a/k/a "receiver." In return for possible benefits to be received in the future, both named parties agree to the following terms of disclosure:

1 Provider agrees to disclose a confidential idea that is believed by the provider to have exceptional marketing value to the receiver.
2 Receiver agrees that the idea to be disclosed is and shall remain the intellectual property of the provider until such time as a mutually acceptable agreement for the transfer of said property may be formally entered into.
3 Upon request of the provider, the receiver shall

immediately return all documents and other items associated with this Disclosure and shall not retain any unauthorized copies or likenesses.

4 Receiver agrees not to disclose or attempt to implement any of these confidential ideas to others, inside or outside (prospect name), its parent company, and/or affiliates in any way without the prior consent of the provider.

It is understood that this agreement does not cover ideas that were already in the public domain or that were already legally known to the receiver prior to their disclosure by the provider. This agreement may be terminated or amended at any time by mutual agreement of both parties. Signatory acknowledges that he/she is authorized to sign on behalf of (prospect name).

X _____ ___/___/___

Print name _____

Title _____

Please sign, scan, and return the endorsed document to (your email address). Upon receipt, said confidential concept will be delivered to you for consideration.

While it's true that cold concepts like the two examples I've cited in this chapter certainly have the potential for a big payout, understand that realistically they're also a big crapshoot. They take time to research, plan, and craft with little to no chance of actually being acted upon. The upside is that if you're pursuing any of these opportunities on downtime, you're not taking billable time away from work in progress.

I'm told that there are many other, far easier ways to possibly generate income when things are slow. One approach may be to sell your design rejects and leftovers through stock marketplaces. Searching "sell designs online" will link you to more than forty (as of this writing) business sites that purchase or trade everything from logos to web templates to photos. I include this as a point of information only; photography aside, as a design professional I can't say that I advocate the purchase or sale of secondhand or stock design solutions.

11

SIDESTEPPING OBSTACLES IN YOUR FIRM'S PATH

GETTING PAST THE GATEKEEPERS

It's certainly no surprise that voice mail has become the norm in today's business world. With very few exceptions, companies have found that productivity increases and salary requirements drop when calls that once were answered by secretaries can be fielded electronically. It's tough enough getting through to people when you actually have something of substance to say; when the call is to inquire about selling your services, voice mail can present a daunting hurdle

indeed. Here are two ways that I've found to break through to the prospects you want to reach:

1. Try calling either very early or toward the end of the workday. For some reason, I've found that the people you're trying to reach seem to pick up their phone more frequently during those time periods. If you do connect to voice mail, make certain that you have a good *reason* for wanting to speak to the party you're calling. Simply wanting to introduce yourself as another design resource hoping for an appointment is generally *not* viewed as a good reason.

2. Cite a referral if possible. Messages that include a referral (e.g., "Jim Smith of XYZ company had suggested that I give you a call") are certainly more likely than others to elicit a callback. No referral? Try some other connection that may resonate with your contact: Pose a relevant question about some company-related issue, comment on or question something you've seen on the company's website, ask about policies relating to a marketing campaign—the list goes on and on. I'm sure you get the picture.

The key to successfully breaking through barriers such as voice mail and/or gatekeepers (secretaries, receptionists, etc.) is simply to keep the short time you're allotted relevant to the party you're trying to reach. As I've said before, my approach is to figuratively put myself in the other person's

shoes; doing so generally gives me a pretty good indication of how I can expect him (or her) to react to my overture.

Although email may present a less intimidating venue for communicating—especially when it comes to "cold" contacts—the formidable gatekeeper here is without question the subject line; if it's not short, compelling, and relevant enough, you can be pretty certain that your message will end up being deleted—or worse, being relegated to junk mail—meaning that future contact attempts will never reach your intended party.

Here are a few general rules to consider in structuring actionable subject lines:

- Keep your subject line as short and succinct as possible; remember that they're often cut off in your recipient's in-box.
- For that reason, try to "front-load" your subject line with key wording.
- Don't waste space using your company name in the subject line, since it will automatically appear in the "from" field.

DEALING WITH DEADBEATS

Every designer I've ever known can relate often harrowing stories of nonpayment. It's almost as if it were a rite of passage in this field—certainly not a mark of honor, but a bond

that we all share at one time or another (and regrettably, sometimes much more than once). I say this at the outset to let you know that you're not alone. I feel fortunate that I can count incidents of nonpayment on the fingers of one hand. I'd like to think the reason for that low figure over the course of a four-decade career is that I learned a painfully valuable lesson from each occurrence and took measures to ensure that I wouldn't get burned again by the same situation.

From my experience, the keys to preventing nonpayment incidents can be summed up in these six commonsense steps:

I. Run your business like a business. As I've stated throughout this guide, businesspeople all too often tend to view designers as "flighty" artists who care far more about design aesthetics than they do about business formalities. The result of that mindset is that unscrupulous clients will sometimes take advantage of those they consider vulnerable. The solution? Don't invite exploitation. Learn and practice accepted business protocols, and I guarantee that you'll no longer be looked upon as a "mark."

2. Get it in writing. Far too many designers seem genuinely distressed about presenting clients or prospects with agreements to sign, usually out of fear that the client will either back out of awarding an assignment or become insulted that your trust in his or her promise to pay for the services ordered would (gasp!) require a signed document as backup. Whether

a new or repeat client, remember that these are the same folks who sign for a myriad of both high-end and everyday credit purchases every day without ever thinking twice about it.

3. Cover contingencies. Remember that the effectiveness of the work agreements you prepare are only as strong as the eventualities they address. Think through your proposal to its eventual outcome and try to plan for and address potential roadblocks by (a) building in provisions for the level and number of edits that you're willing to undertake before charging additionally for them, (b) incorporating progressive billing provisions to ensure an ongoing cash flow should the project you're about to undertake extend beyond a defined time frame or expand beyond the scope of your original proposal, and (c) stipulating notification and a "kill fee" should the project be canceled prior to its conclusion.

4. Think like a lawyer. When professionally written and properly endorsed, your signed proposal will serve as a legally binding document should disagreements occur. Make certain that your contact (or whomever you present your proposal to for endorsement) has the *authority* to sanction the work you're proposing. I've found that the best way to avoid disputes and quell challenges is to document every-thing—edit rounds, cost overruns, client-initiated changes, specifications, and so forth—in writing. Change orders or even simple email communications offer an ideal means of chronicling ongoing notifications and directives between

the parties. In my own experience, while certain boilerplate information remains the same from one proposal to another, all documents should be custom-crafted to reflect the scope of the work being proposed. I've tried to provide examples of that within the pages of this guide. If you need more help, I recommend the book *Business and Legal Forms for Graphic Designers*, by Tad Crawford and Eva Doman Bruck.

5. Check credit references. Obviously, if your new client is a Fortune 500 company, this step is less of a necessity. With smaller clients, however, it's an expected and perfectly acceptable business practice to check credit and payment histories with the company's business bank as well as with other vendors with whom the client has ongoing business relationships. Unless your potential client is willing to provide you with the authorization required to access specific account information, don't count on cooperation from the bank. The one noninvasive question that the bank usually will answer is the number of digits in the client's average daily balance. Ask your prospects for at least three credit references from vendors with whom they have ongoing relationships. You can access credit reference request online templates that cover credit limits, terms, and payment history.

6. Ask for an advance. This step applies equally to any project originating from a new client and to any large-scale project assigned by any client, new or current. Depending on the

scope of the assignment, I may request a 50 percent advance on single-delivery projects and one-third up front on multi-phased assignments. I've found that most reputable clients will unquestioningly comply with this request.

WHEN GOOD PROJECTS GO BAD

This is a good segue for sharing two pointed examples of why being unshrinking in standing up to corporate bullying and being smart by insisting on documentation can often spell the difference between getting burned and getting satisfaction when things go south. Read on.

Standing Up to a Corporate Bully

Through a social connection, I had begun doing business with the corporate counsel of a mid-size oil and gas exploration company some time ago. My firm's assignments from this client typically entailed the design and preparation of marketing literature for limited partnerships that the company was pitching through various brokerage houses. Visually, these materials were intended to send a message of financial strength and confidence to potential investors. As such, they were designed as extremely attractive pieces, expensive to produce and very profitable for my firm. So when this client asked me to prepare the company's annual report, it was a given that beyond satisfying basic SEC requirements, the report would have to visually support and communicate the

success the company had achieved. No sooner was my pro-posal accepted than I learned that in place of dealing with my usual contact, I'd be working directly with the company's chief financial officer.

Everything on the design side of this project had been progressing smoothly—that is, until the two-round inclu-sion limit on handling "reasonable and customary" edits had been reached. Once additional time and expense charges were billed, I began catching grief from the CFO. In the overall scheme of things, these charges were perfectly nor-mal fees that are considered part and parcel of a project of this scope, fees that, prior to working with this person, had always been paid promptly and without incident. I soon real-ized, however, that this person (I'll call him Alan) had never before worked with a design firm; rather than attempting to understand the process and work *with* me, he fell back on the only strengths that he seemed to be comfortable with: nickel-and-diming every expenditure in an adversarial and counterproductive way. There was no question in my mind that this project was going to spell trouble for me going for-ward; I just didn't realize how much trouble until the job went off to be printed.

Although we had allocated ample time to strip, plate, run, score, and bind this complex project (6-color plus lamination, 28 pages plus cover) in order to deliver all 5,000 copies the day before the company's annual shareholder meeting, the very day that proofing was okayed, Alan demanded a two-

day turnaround of 100 hand-bound, stitched, and trimmed copies for internal distribution—a demand that threw the production schedule off course by two days: a demand that he didn't feel he should have to pay any extra for. When my attempts to reason with him on that point fell flat, I pleaded with the printer to accommodate this ego-driven crank because of the dollar amounts involved, the no-problem track record with the client up until now, and, frankly, just to get this job over and done with and to move on.

Bottom line: Alan got his copies and didn't pay any extra for them. But rather than thanking me for expediting those hand-bound samples, once he had them in hand he immediately went to work examining them with a fine-tooth comb, finally finding a small hickey on the full-bleed inside cover likely caused by a piece of dust that had been picked up from rushing the job through without allotting proper drying time. By now, of course, the full run of covers had been completed and headed to the bindery in order to meet the delivery deadline. As expected, Alan's reaction was that he wanted an accommodation for the less-than-perfect cover. Again I tried to reason with him, and again he wouldn't budge. Generously, the printer agreed to eat a percentage of his profit—a percentage, by the way, that also ate into my commission.

When I presented this offer to him, Alan—no doubt sensing the power he now held over us—turned around and suddenly refused to pay *anything* for the job, saying that it

was below his expectations. I thought I was going to explode with rage. This was serious business, with tens of thousands of dollars on the line and a CFO who signed the checks. To my mind, the time for accommodations had ended; this was the final straw. In desperation, I called my previous contact at the company to plead my case and to ask if he would intervene. Sympathetic as he was, he let me know that this was my battle alone to fight; not surprisingly, I learned that this wasn't the first time that Alan had pulled something like this on vendors, nor would it likely be the last.

Well, it certainly would be the last with me; I realized that at this juncture, whatever the outcome, I wouldn't be doing any further business with this client and so had nothing to lose by standing my ground. With the delivery date only days away, I quickly came to realize the leverage that I held. I told the printer not to deliver *anything* until he heard back from me. I then called Alan and told him that I would be holding delivery of the job until I received payment—in full, and by certified check the following day. He went ballistic. The company had spent heavily arranging for more than five hundred shareholders to be luncheon guests at a midtown banquet facility for the company's annual meeting, the highlight of which was to be distribution of the elaborate annual reports that we had designed.

As he came to realize that the tables were suddenly turned and that another day had slipped by, Alan grasped the gravity of the situation and cut me a check that morn-

ing covering the full amount. When it arrived, I saw that it wasn't certified—he was still playing games with me. I had no doubt that he'd issue a stop payment order just as soon as I gave the printer the go-ahead to deliver. I returned the check to the waiting messenger with a note saying that any further delaying tactics would see all of the reports destroyed. In just under an hour, I had a certified check for the full amount in hand that was quickly deposited in my account.

As expected, I lost the account after that but gained a real sense of elation (as well as more than a few gray hairs) at having beat this bully at his own game. Lesson? Some insecure people feel the need to use their positions in order to demonstrate their authority, especially with those they sense can easily be pushed around. Stand up to corporate bullying—the cost isn't worth the client.

Making the Case for Documentation

When Gary, a former client of mine, took an executive management position with an out-of-state company, I normally would've assumed that the move would mark the end of our professional relationship, but that isn't necessarily the case anymore; the ability to communicate electronically has effectively torn down geographic barriers for all design firms.

And so, within weeks of his settling in, I received a call asking me to quote on developing some ads that he was working on. My quote was delivered via email and approved within days. That initial assignment opened the doors to a

host of new business for me, with all work being handled through a combination of phone, fax, email, and PDFs.

About a year or so into his new employment, Gary, who had a long entrepreneurial history prior to accepting this position, apparently once again began sensing the need for independence and so surreptitiously planned his departure, a departure that would include taking two other key employees with him in order to start a rival company. I, of course, wasn't privy to any of this; the projects we were being assigned kept coming in on a pretty regular basis. In fact, I was only made aware of Gary's plans well into a complex assignment that involved developing templates for standardizing all of the company's sales collateral. It was then that Gary called to advise me to bill for any work we did up to this point "just in case." That same day I prepared and mailed my invoice—which was approved by Gary and passed along for payment, same as always.

By week's end, however, I learned that Gary and the two other employees who had been planning to leave with him were all summarily escorted from the building under guard. Stunning as this news was, my guess was that since my invoice was well along the payment chain, this pivotal event wouldn't impact my getting paid. Well, readers, that guess was incorrect.

Because he had been hired directly by the company CEO, and because Gary had been responsible for bringing me onboard, I was now considered persona non grata as well.

Simply put, when the accounts payable chain reached the CEO, he refused to endorse my check. Of course at the time, I didn't know any of this; and so, after some 45 days had come and gone without receiving payment, I placed a call requesting status to the only other person I had ever been in contact with at the company. It was only then that I was told of the decision not to honor my invoice.

My very next call was to the company's legal department citing my email correspondence with Gary, who at the time of our agreement had full authority to authorize the work in question. I made it clear that regardless of circumstances, I was not about to stand for any impediment to being paid in full. I further stated that if I didn't receive payment by the following week, I would invoke the 1.5 percent service charge on the unpaid amount as stipulated on my invoice.

The legal department responded with a request to review the correspondence, documentation that it had never been made aware of. Within days of sending that material, I received payment in full via FedEx. Had I not insisted on written approval, I would never have had the backup necessary to support my case. Lesson? Put *all* work agreements, no matter how casually composed, in writing, and get approval for them—also in writing—before proceeding. While work agreements consisting of simple back-and-forth emails outlining and approving project or detail particulars can be legally binding, if you really want to avoid potential trouble, learn how to think like a lawyer in composing *any* commu-

nications that involve the transfer of money. Remember: The more professional and complete your correspondence is, the less likelihood there will be of running into problems going forward.

A SOBERING REALITY . . .
and a bright outlook

As of this writing, two powerful forces have joined to create a near-perfect storm for many small, independent design firms. First, the popularity of graphic design as a college major has produced a glut of new designers entering the field each year. Second, cutbacks both in hiring and in outside budgets for most companies have severely limited opportunities for the small design firm. And to make matters worse, online brokers now offer to connect clients globally with vendors offering cutthroat pricing for design and production services that until recently had been the exclusive domain of domestic firms.

Throughout this guide, I've attempted to address this new reality by offering ways in which to stand out in today's crowded and often undervalued marketplace. The reality of the situation is this: Whatever the economic climate, there will always be success stories and there will always be failures. On the bright side, the failures thin out the competition, opening up more doors for you to knock on. There are three keys to succeeding in this environment: (1) understand

both your competition and your target market, (2) define a viable niche for yourself, and (3) aggressively market those strengths that will provide genuine bottom-line value for your clients and prospects. In the age of the Internet, nothing is beyond your reach; opportunities to shape and market the firm you envision have never been greater if you're willing to commit the time and energy necessary to achieve your goals.

A FINAL WORD (OR TWO)

My hope is that this guide has provided you with the inspiration, motivation, tools, and ideas you'll need to succeed in this largely satisfying, sometimes frustrating business of ours. It's important to remember that there's no single measure of success; real success is the attainment of those benchmarks that you've set for yourself.

Just remember:

- Set your professional standards high in *every* aspect of your business dealings and commit to strengthening those areas of weakness that need it; remember that you'll always be judged on levels other than your design abilities.
- Regardless of how talented you think you may be, keep your ego in check; demonstrating an exaggerated sense of your own importance to a client or prospect is a sure-

fire prescription for being replaced. Always remember that the world will keep on spinning whether you're onboard or not.

- Always assume that your competition is knocking on your client's door—go the extra mile in providing a range and depth of knowledge and services that will keep clients coming back.

The steps I've outlined in this guide have been culled from four decades of real-life experience and compressed to focus on those actions that I feel will best support your goal of setting up and running a respected and profitable graphic design firm. Should you care to discuss any specific issues not covered here, I'm available to consult with you one-on-one. You can contact me at ldandesign@aol.com. Be sure to put "Design firm query" in the subject line to ensure that your email is not treated as junk.

I wish you every success in your venture.

INDEX

accountant, 25
ad agency, acting as, 51–53
ad mock-ups, 52
advance payment, asking for, 212–213
advertising, 172–173
 client fronting cost of, 54
agreement
 handshake, 8
 nondisclosure, 202–205
 for partnership, 8
 retainer, 8–9
 retainer, example, 9–11
 written, 210–211, 219
American Institute of Graphic Arts
 (AIGA), 26
American Stock Exchange, 39
Andrew, Gordon, 39
announcement of openings, 53–54
anxiety-producing situation, 91
attorney, 8
authority of contact to make
 commitment, 211
awards, 159
 participation in industry shows, 17
"away" notice on voice mail, 135

B2B advertising, 172–173
bartering services, 38
baseline time rates, 122–123
big clients, connecting with, 192–195
billable time
 rates, 123
 tracking, 124–127
billing information, tracking, 130, 132
bio page on website, 72–73
blog, Q&A format, 195–199
bookkeeping, 25–27
Boston Globe, 53
boutique shops, absence of appeal, 2–3
brand identity, 190
 proposal example for developing,
 111–115
brand voice, 15–19
brochure, 78–79, 171
Bruck, Eva Doman, *Business and Legal
 Forms for Graphic Designers*, 212

budget, 105
business
 designing for, 69–70
 focus on defined practice area,
 65–66
 reasons for survival, 19
 structure, 23–25
 time for critical elements, 7
business address, 27–29
*Business and Legal Forms for Graphic
 Designers* (Crawford and Bruck),
 212
business cards, 92, 146
business centers, 28
business cycles, 2
business demographics, advertising in
 publications targeting, 172–173
business plan, need for, 14–15
business writing, 93–100
 contact introduction letter, 96–98
 follow-up letter, 99–100

C corporation, 24
call to action, 116, 166
cancellation of project, 118
capabilities brochure, 171
capabilities page on website, 72
career path, 4
cash flow, 64
 managing, 60–64
certified public accountant (CPA), 25
change, 41
change orders, 211
Citibank, 33–34
Client Satisfaction Survey, 157–158
clients
 accountability to vendors, 48–49
 connecting with prestigious, 192–195
 core communication problem, 69
 directly contacting, 5
 fronting cost of advertising, 54
 gift-giving, 148–150
 graphic standards from, 141–142
 loss of, 36
 perceptions of business, 16, 81–86
 proposal acceptance, 109, 110

clients (*continued*)
 relationships with, 188, 191–192
 research on, 43
 testimonials, 73, 151–158
 viewing relationship with, 188
cold calling, 160–170
collaborations, 45
comfort zone, with prospective clients, 142–143
commission, in estimates, 48
commitment, to employees, 183
company name, 15, 16–17
competition
 assumptions about, 222
 understanding fundamentals, 67
complexity, 106
confidential disclosure agreement, 202–205
contact introduction letter, 96–98
contingencies, in agreement, 211
copyright notice, 195–196
corporate bully, standing up to, 213–217
corporate chemistry, 190–192
corporate design, 16
corporations, 24
correspondence, *see* business writing
costs, managing big-budget, 47–48
Crain's New York Business, 173
Crawford, Tad, *Business and Legal Forms for Graphic Designers*, 212
creative brief, 102, 107–108
creative process, approach to, 103
creative rights, 118
credibility, 81–92
 "four P's," 82–86
credit references, 212
cultures, adapting to, 190–192

DBA (Doing Business As) registration, 23–24
deadbeats, 209–213
deadlines, 22, 103, 105–106
deliverables, rationale for concept development, 116
design
 capabilities reflected in website, 71–74
 vs. real-world problem solving, 4
design firms, size of, 189–190
design magazines, advertising in, 172–173
difficult people, 42

discipline, in time management, 121
documentation
 importance of, 217–220
 of project activity, 132
downsizing, commitment to employees and, 183
downtime, 38, 135–137
downturns in economy, 34, 45
 market crash of 1987, 181
dressing appropriately, 85
due dates, 22

"eggs in one basket" syndrome, 180–185
email, avoiding for sending sales materials, 94
email accounts, 135
employees
 commitment to, 183
 vs. freelancers, 187
entrepreneurship
 advice for, 39–41
 reality of, 1–3
 tasks required, 2
equipment, 3
expectations, of prospect, 84
expenses, 117
Express Mail, 163

feast-or-famine lifestyle, 35
FedEx, 164
fees, 31, 117
 estimate of, 109
 generally accepted, 123
 markups, 30–31, 48
 monthly retainer, 8–9
 negotiating adjustments, 115–116
 see also invoicing
finances
 budget, 105
 loans, 15
 record keeping, 33
financial services, 182–183
flexibility, in time management, 121
folder art, for sales materials, 95–96
follow-up letter, 99–100
Fortune magazine, 200–202
freelancers
 vs. employees, 187
 outsourcing to, 61–62
freelancing
 experience before, 4
 by telemarketer, 164

gatekeepers, getting past, 207–209
generally accepted hourly fees for services, 123
geographic barriers, removal of, 217
Gerber, Michael, *The E-Myth*, 40
gifts for clients, 148–150
Girl Scouts, 35
goals, defining, 14
grammar, 94
graphic designers
 commercial, 104
 creative solutions, 104
 decline of supporting businesses, 31
 early missteps as entrepreneurs, 3–6
 popularity for college students, 220
 self-employment, ix
Greenawalt, Peggy, 41–43
growing firm, 187–205

Haas, Ed, 34–37
handshake agreement, 8
hiring, cutbacks, 220
home office
 operations, 28
 reasons for not having, 28–29

image, 65–79
income streams, mining other, 200–202
indemnification, 49, 118–119
independence, failure vs. working for others, 6
individualism, in creative process, 103
industry awards shows, participation in, 17
insertion order template, 55
institutionalizing business, 40
integration, of design parameters, 106
investment program, 184
investors, 3
invoicing, 59–60
 progressive, 64

job tickets, 132

Kaeser and Wilson Design, 45

lawyer, for business structure advice, 25
leases, 28
ledger, 58–59
legally binding document, 211
LegalZoom, 25
Limited Liability Corporations (LLCs), 24

Limited Liability Partnerships (LLPs), 24
loans, ability to gain, 15
location, 27–29

Macintosh computer, 31–32, 189
mailings, New Year's cards, 170–171
managed services, 30–31
management
 of big-budget costs, 47–48
 of cash flow, 60–64
market crash of 1987, 181
market niche, decisions on, 16
marketing, 139–185
 promotional, 170–178
 sales, 139–140
 websites for, 175–176
marketing managers, 8
markups, 30–31
 in estimates, 48
media commissions, 51–54
micromanaging, 181
monthly retainer, 8–9
motivation, 21, 39
moving announcements, 171–172

name recognition, 18–19
names, remembering, 91–92
negotiable issues, 38
negotiating fee adjustments, 115–116
nest-egg building, 184–185
net worth, 2
networking, 37, 145–147
new business, 40
new projects, start-up package for, 127–130
New Year's cards, 170–171
New York Road Runners, 177–178
news column, Q&A format, 195–199
news media
 cold calling opportunities from, 161–163
 mining, 195–199
 responding to, 200
noncompete clause, 194
nondisclosure agreement, 202–205
nonpayment, 209–213

obstacles avoidance, 207–222
 gatekeepers, 207–209
office
 renting, 7, 122
 subletting portion, 29, 63

online stock libraries, 45
outsourcing, 61

partnership, 6, 7–14
 failure of, 12
 issues to consider, 13–14
 perception of others on, 12–13
payment, 117
peer recognition, 159–160
perceptions
 art of shaping, 187–188
 by clients and prospects, 81–86
 reality shaped by, 88–89
persistence, credibility and, 85–86
personal commitment, 17
personal liability protection, 24
personality
 adapting to, 190–192
 credibility and, 83–84
photographers, business of, 35
portfolio, 74–77
 credibility and, 82–83
 page on website, 73
 vs. website, 36
praise, 151–158
presentations, 74
 honing skills, 87–89
 overcoming jitters, 89–92
pricing, 31
 see also fees
print production spec sheet, 49–51
printed samples, 75–77
printers, 32
 quote comparison, 49
priorities, 22
pro bono work, 177
 anti-littering campaign, 178, 179
professional publications,
 contributions to, 17–18
professional standards, 221
professionalism, credibility and, 84–85
progressive expenses, tracking, 134,
 135
progressive project expense sheet, 134
project content folders, 132, 134
project cost summary sheet, 128
project cover sheet, 130, 131
project identification, 130
 assigning, 56–58
project trafficking sheet, 132–134
projections for presentation,
 limitations, 75
projects, going bad, 213–220

promotional items, value of, 147–148
promotional marketing, 170–178
proposal worksheet, 110
proposals, 101–119
 acceptance by client, 109, 110
 establishing creative methodology,
 103–119
 example for brand identity
 development, 111–115
 impact on relationships, 101–102
 for Q&A column or blog, 196–199
proposals/work authorization entry
 log, 127, 129, 130
proprietary information, security for,
 119
prospects
 comfort zone with, 142–143
 offering unsolicited critiques of
 materials, 83, 87
 research on, 84, 86–87

Q&A format, for news column or blog,
 195–199
qualifications, showcasing, 70–79

rates, 15–16, 123
 see also fees
receivables, documenting and
 tracking, 58–59
referrals, 144–145
 to get past gatekeeper, 208
rejection, reaction to, 40
relationships, 37–38
 with clients, 188, 191–192
 proposal impact on, 101–102
relevance, 89
remembering names, 91–92
renting, 28
repeat business, 140
reproduction rights, 118
reputation, building, 177
resale certificate, 59
retainer agreement, 8–9
 example, 9–11
running business, challenge of,
 140–142

S corporation, 24
sales and marketing, 35–36, 139–140
 message on primary strength, 69
 showcasing qualifications, 70–79
 style matching personality, 38
 tracking efforts, 56, 57

sales materials
 avoiding email for sending, 94
 folder art for, 95–96
sales-tax requirements, of designers,
 26–27
samples
 start-up design firm's lack of, 83
 on website, 74
scheduling, 105–106
script, for telemarketer, 165–169
security, for proprietary information,
 119
self-discipline, 21–22
self-promotion, 143–150
service quality, 42
shareholders of corporation, 24
Shenker, Nancy A., 33–34
skills, 42
slow periods, 38
Small Business Administration (SBA),
 15
small talk, before presentation, 91
social media, 34, 176–178
social networking, 145
sole practitioner, success of, 37–39
speech coach, 91
start-up package, for new projects,
 127–130
stock marketplaces, 205
strategic alliances, 29–30, 61
success
 key factors, 44
 self-discipline and, 21–22

talent pool, 45
target audience, understanding
 fundamentals of, 67
tax accountant, for business structure
 advice, 25
tax issues, 26
tax reports, 137
telemarketing, 164–170
testimonials, 73, 151–158
 examples, 153–157
 requesting, 152
thank-you cards, 149–153
third-party endorsements, 73
time
 for business activities, 7
 limits for rate guarantees, 119
 management, 121–137
 tracking, 58
time sheets, 124, 125, 126

"to do" list, 22
Tomases, Faith, 37–39
tracking
 billing information, 130, 132
 receivables, 58–59
 sales and marketing efforts, 56, 57
 time, 58
trade name, 23
trade shows, 173–175
traffic sheet, 132–134
Travelers Insurance Group, 37
trust, 5
typography industry, 31–32

unique selling proposition (USP),
 66–69
UPS, 164

vacation, 135
vendors, 29–30, 32
 client accountability to, 48–49
 client choices, 30–31
 payment for markup, 48
vision, vs. marketplace reality, 141
voice mail, 135
 getting past, 207–209
volunteering, 177

Wall Street Journal, buying space in,
 53
"we" approach, 187
website
 design capabilities reflected in,
 71–74
 for marketing, 175–176
 vs. portfolio, 36
Wilson, Annalee, 43
women-owned business, 43
work environment, 22
working from home, reasons for not,
 28–29
work in progress bin, 132
workaholic, 136
work-for-hire arrangement, 4
working capital, business plan for
 raising, 14–15
worldview, importance of taking,
 142–143
writing skills, importance of, 93–94
written agreements, 210–211
 importance of, 219

Zippo company, 200–202